Patrick Lichfield's UNIPART
CALENDAR BOOK

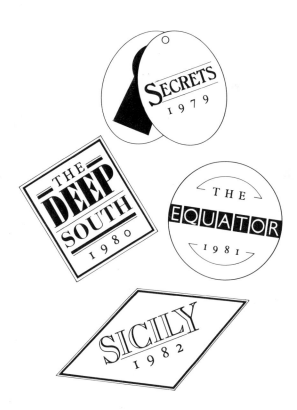

SECRETS 1979

THE DEEP SOUTH 1980

THE EQUATOR 1981

SICILY 1982

Front cover

Legs shot: One of the ones that got away. Suzi's spectacular legs, caught in the dawn light in a French barn. 'They elbowed it,' says Lichfield, 'perhaps because she's not actually looking at the camera.'

Umbrella shot: They wanted to show they were very definitely at the Equator, proof positive that all that travel had been to get somewhere special. And they wanted a vulture. Happened the day when there was the perfect bird, up in an acacia, and the sun blistering down on Melissa from practically dead overhead.

Back cover

Patrick Lichfield with his two assistants, Chalky Whyte and Peter Kain, on location in Kenya.

Opposite and overleaf

A shot for the 1979 Calendar: France – and a fraud. Georgie is nowhere near the sun-drenched Ardèche. She is, however improbably, painting a picture of a supposed French chateau in the middle of the lawn of Aubrey House, not a hundred yards from the Lichfield studio. And all because they wanted a picture of a girl painting a chateau; it took the art director's wife, back home, to do that part.

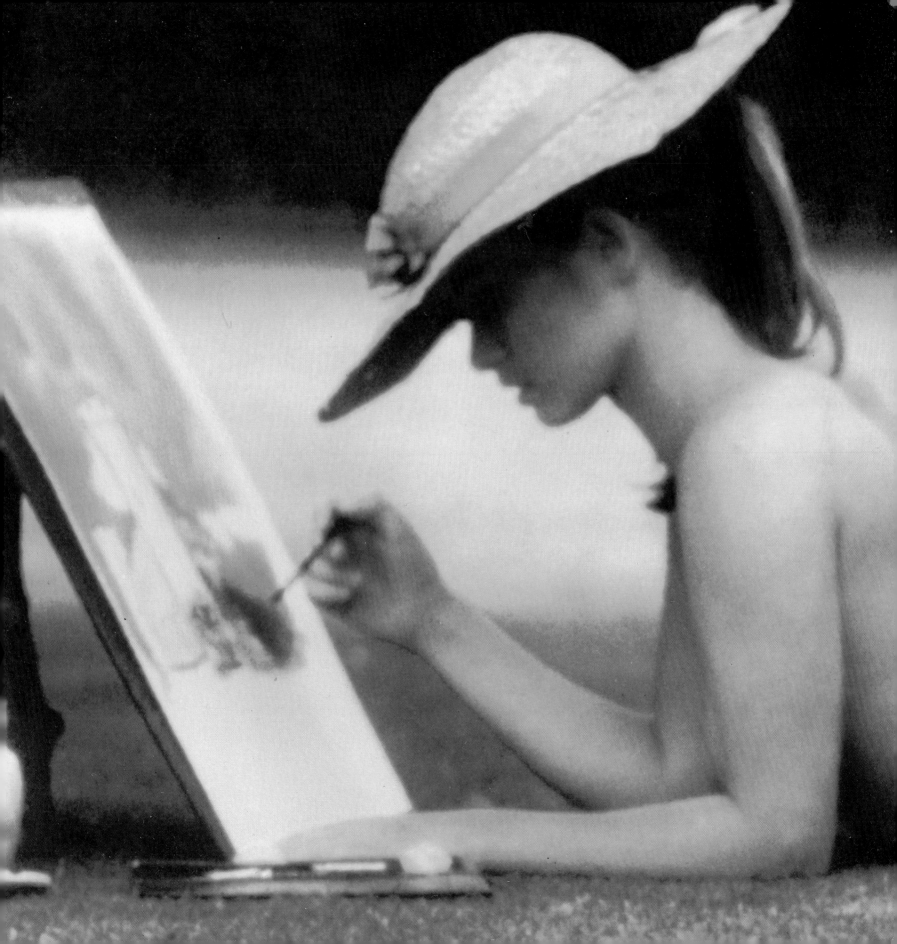

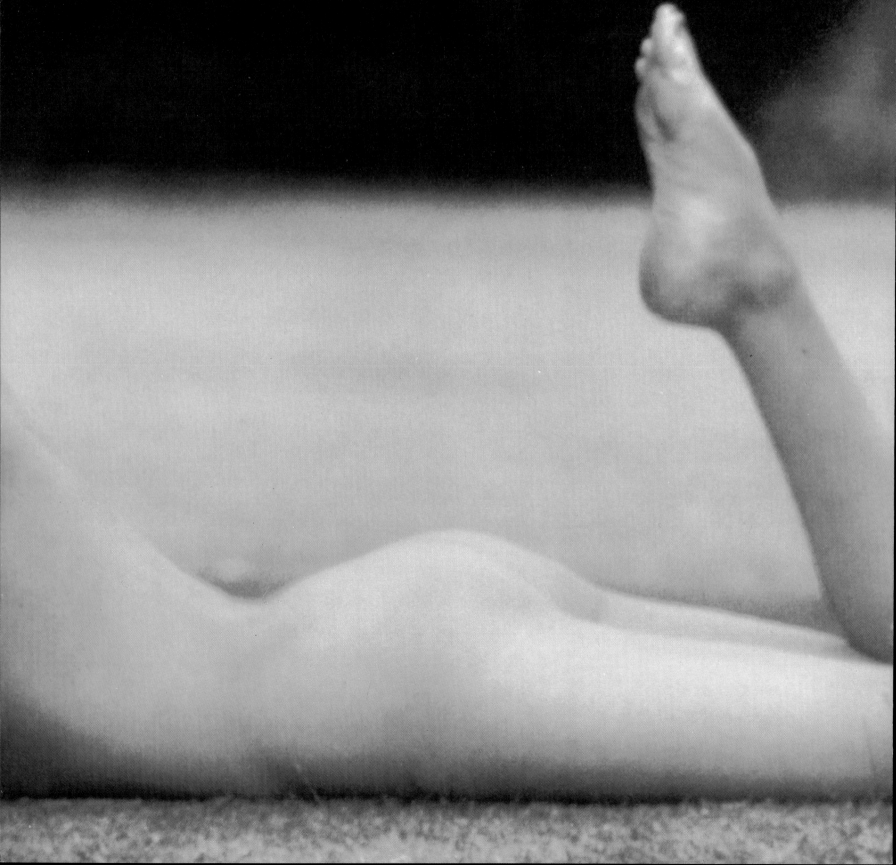

Patrick Lichfield's UNIPART
CALENDAR BOOK

Patrick Lichfield
with text by Richard North

COLLINS
St James's Place, London
1982

Books by Patrick Lichfield

The Most Beautiful Women
Lichfield on Photography

William Collins Sons and Co Ltd
London · Glasgow · Sydney · Auckland
Toronto · Johannesburg

First published 1982
Reprinted 1983
© Photographs: Unipart Ltd 1982
© Text: Richard North 1982

Designed by Ashted Dastor
Set in Plantin Light & Futura Extra Bold
Made and Printed in Great Britain
by William Collins Sons and Co Ltd Glasgow

CONTENTS

Preface *page* 9

1. The Photographer 11

2. The Art Director 19

3. The Fixer 23

4. The Stylist 25

5. The Make-up Artist 29

6. The Assistants 33

7. The Models 36

8. The Client 42

9. The Punter 43

THE PLATES

Secrets 1979 44

The Deep South 1980 58

The Equator 1981 78

Sicily 1982 92

Technical Note 112

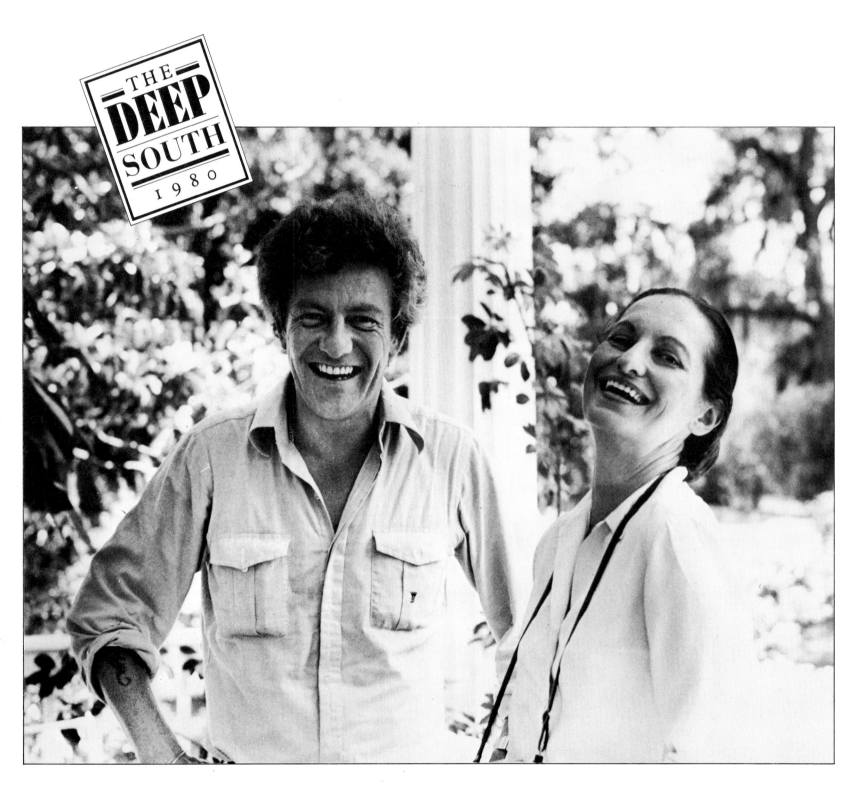

THE
DEEP
SOUTH
1980

PREFACE

Every year, in high summer, an intrepid party of British (and one emigreé French woman) set off for somewhere beautiful. Their task (if task it be) is to come back with stunningly pretty and sexy shots of girls, from which a motor spares company, Unipart, will select the twelve which will chart the waxings and wanings of the moon in what some of the men involved in the venture quite shamelessly call 'crumpet'.

Twelve lovely pictures of special, fantastic, idealized girls. Twelve images to make January less chill, March less blowy, June less drizzly. Twelve snaps of ladies, with which to soften Quarter Day, or the overdue credit card payment, or the gentle, steady erosion of the family saloon by rust – all of them inexorable ways of measuring the passing of time.

Time, ageing – all discomforts and unpleasantness – are banished from these pictures.

This is the task of a team, headed by Patrick, Lord Lichfield, and mightily abetted by his henchmen, and that one Frenchwoman and – of course – the girls themselves.

The text of the book, threading its way through the pictures, aims to introduce you to some of these characters.

Everyone of them believes he or she has a bigger role than the others would admit. It is part of the fun of the venture that they all seem rather roundly to tell one another that this is the case. And then, the rows over for the time being, they go off to dinner together.

The whole enterprise – from planning, through the picture-taking, and doubtless including the moment when the twelve final pictures are chosen from the best twenty-odd (in a process which must match the Tories finding a leader, or the Church of Rome discovering its Pope) – all of it is punctuated by a fair amount of jollity and light carousing.

This is not a book about the greatest triumph for art and mankind that human genius has yet to attain. The Unipart Calendar, whatever it may be, is not the Sistine Chapel.

But it's good fun and – with any luck at all – this book will convey that amongst the talent, sweat and pallaver that goes into its making, there is also a deal of plain good-timing.

The Unipart Calendar is about pretty girls helping to sell bits of motor car. An unholy alliance.

Still, motor parts salesman and the garage mechanic deserve at least as much as anyone else to have their day brightened.

If you think a photographing Lord must always have had it cushy; that all half-dressed models are exploited; that it's all just a simple case of snapping – read on. This little tome may hold a surprise or two.

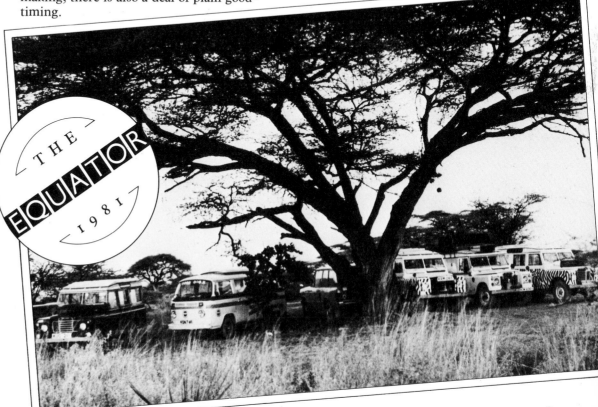

Have Calendar, will travel: Patrick with the owner of the South Carolina plantation, where the team could work comfortably and undisturbed; and (right) remote Shaba camp in Kenya, an acacia providing the only shelter from blistering sun.

THE
DEEP
SOUTH
1 9 8 0

1. THE PHOTOGRAPHER Patrick Lichfield

On 19 October 1962, Her Majesty's armed forces lost a lordly lieutenant, and Chelsea, Fulham – and indeed the entire world – gained a photographer. He didn't know much about his new trade: he'd read a manual through a couple of times and had scraped together incremental pocket money at school (Harrow) by rooking his fellow pupils for the odd portrait.

For someone who was so well-heeled, Thomas Patrick John Anson, the 5th Earl of Lichfield, Viscount Anson and Baron Soberton, was not well-off. His grandfather and his father were dead; he had a stately home and a hole in his pocket which had a great deal to do with death duties and a notable absence of the kinds of fiddles that other families with more conveniently-timed deaths in them had contrived.

However, if he had a way with stories then the way he has a way with stories now, something of how the twenty-three-year-old ex-Grenadier Guards officer slithered his way up the first crucial feet of the slippery pole which stands between the herd and the few becomes clear. The man could make a Sphinx smile.

But something else was going for him. It was a thing called the sixties.

The honest go-ahead thrusting of the innocent fifties had come to an end. England stopped celebrating America and making money the industrious way. We had had enough of earnest endeavour. We decided, the way the English decide every now and again, that we would dabble our toes in decadence. And we found the thrill didn't stop with our toes.

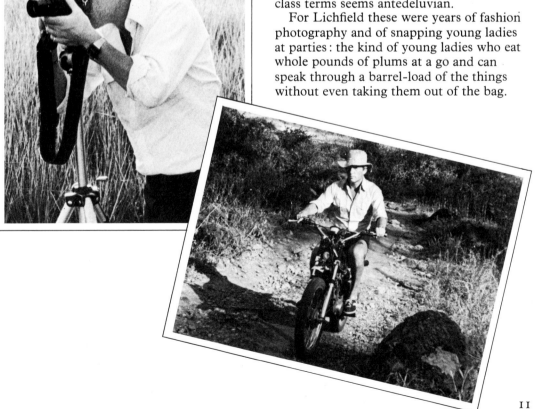

The middle classes took a downer and the only two sorts of people who seemed to have the natural clout to survive and flourish in the new hothouse environment were the lower and the upper strata.

Most photographers who were making their name at that time were in the first category. Bailey, Duffy and Donovan, East Enders all, were sorting out the world of *ton* and fashion in their own way, whilst Lichfield followed Tony Armstrong-Jones, now Lord Snowdon, in batting for the upper crust. Naturally enough, Lichfield – like many a boxing, scrapping, talented aristocrat before him – gets on pretty well with the get-ahead lower orders, though – partly as a result of what happened in the hothouse years – even using these old hat class terms seems antedeluvian.

For Lichfield these were years of fashion photography and of snapping young ladies at parties: the kind of young ladies who eat whole pounds of plums at a go and can speak through a barrel-load of the things without even taking them out of the bag.

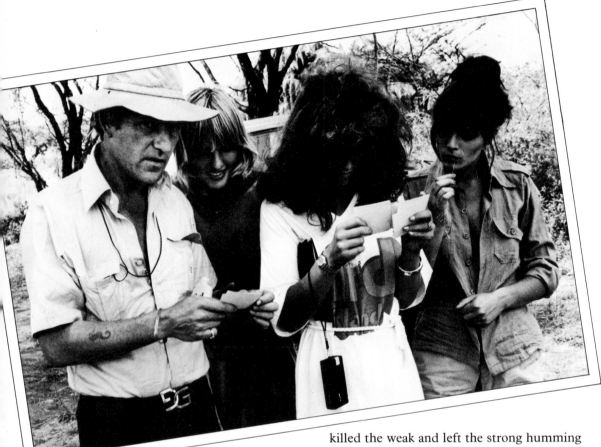

THE
EQUATOR
1981

let it be a good one. 'Lichfield is a very skilful photographer,' says an admirer. 'But what people don't recognize is that he works very hard. He's diligent, and that's what one doesn't expect.'

'He's a very tough cookie indeed,' says Noel Myers, the art director on the Unipart Calendar. 'We worked hard and we played hard,' says Lichfield of the sixties, when he was footloose and fancy free. Now, he is not merely one of the top glamour merchants of his day (and, in the topless stakes, only through his Unipart work): he is the landowning, trim-suited husband of the elegant and composed Leonora, second daughter of the 5th Duke of Westminster. It is said he contrives to shrug off the photographic life and to don the mantle of

killed the weak and left the strong humming with excitement and tension.

They were also the years in which Patrick Lichfield learned and refined his skill to the point where he could have worked as a photojournalist more than he did: if only he hadn't such expensive tastes. But his tumble-down snap after the Royal Wedding betrays exactly the kind of impromptu talent journalistic photography demands.

The success was achieved by dint of high energy and steady application. Lichfield is no dilettante.

'Don't become an interior decorator, a ballet dancer or a photographer,' his mother had cautioned, when he was contemplating the rest of his life from the precarious age of sixteen or so. 'I wanted to do something and do it properly,' says Patrick Lichfield now: so he joined the army full-time, rather than just for national service.

But if, in defiance of his elders and betters, he were to be a photographer, then

He earned £3 a week at first, lived in a flat with a horde of other indigents without his girlfriend's father (the landlord) ever quite working the whole shenanigan out, and learned as much as he could from bosses like Dmitri Kasterine.

It sounds an easy life, yet was probably pretty hard. These were casualty years: years of intense competition for attention, and years of temptation and excess that

rustic responsibility whilst thrumming up the M1 in the silver Mercedes with the curly 'L' enscrolled on the door.

Four Calendars ago, Lichfield drifted into the Unipart job.

'Can you work with this man?' the client, the Unipart man, asked Lichfield? 'I was mad enough to say I could,' says Lichfield,

of Noel Myers. Noel Myers tells much the same story, but out of *his* mouth, the problem is whether Myers could work with Lichfield.

The result is a partnership typical of the kind which often works best. Certainly, it is a partnership which suits the business of generating an attitude out of which fantasies are born. These two probably know about as much as is possible about the bad old world, and they also have an enjoyable passion for creating pretty pictures. Combining a turn-on with art is a game they both enjoy.

They need to. The silly truth is that, whilst most people believe that their longings and yearnings and fantasizings could produce good pictures, only a very few people can actually be guaranteed to take three girls somewhere where the sun shines and to come back with the required twelve snaps which combine sexiness with dignity – God help us, dignity – which will make the pictures acceptable both to mechanics and managing directors. (Not that their *real* requirements are different one from another: only that the lubrication bay has a different feel from the executive suite.)

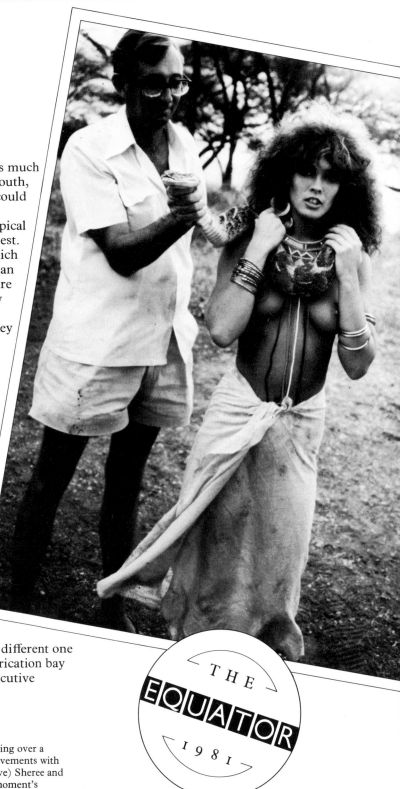

Not swap-shots (top left) but Patrick going over a morning's shoot and working out improvements with the models in Kenya, in particular (above) Sheree and Jonathan Leakey's puff adder. Left: a moment's relaxation with Noel Myers, art director, in Carolina.

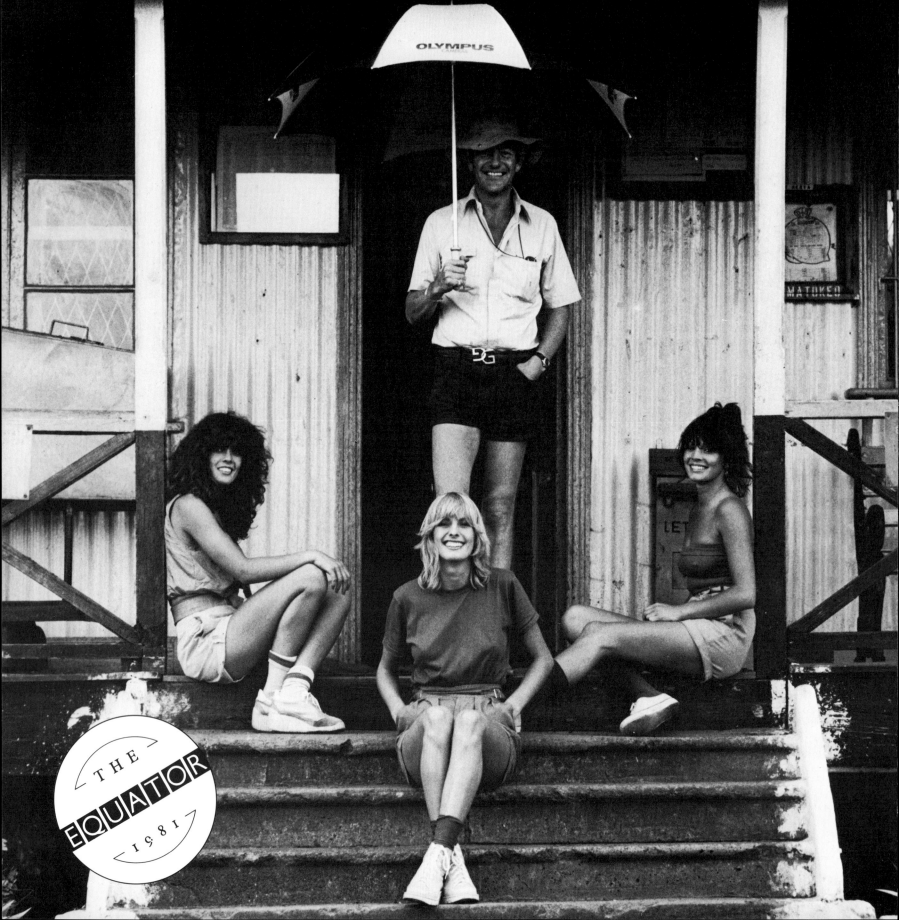

'This Calendar has to be tasteful,' says Lichfield. And it also has to be tasty. Noel Myers and Lichfield seem to alternate as the custodians of the two values.

The result, probably more to do with Lichfield's own pair of eyes than might be supposed from his having up to fifteen people helping him, is a Calendar which is not the usual essay about female flesh. Only one picture in the entire series has provoked much dissent amongst women, and that was a macho effort in which a girl is seen powering her motorbike through the African dust. (Actually, she sat tight on a bike propped by bricks whilst everyone who could wave anything surrounded her with palm leaves whirring up a dust storm.)

Indeed, since the pictures show the female figure at its most pert and boyish, even androgenous, there's even half a thought that, like fashion plates, they strike at the homosexual in women almost as much as the heterosexual in men. Not for nothing is the ideal 'model' almost the exact reverse of what any man would like to go to bed with: they are the platonic notion of perfect woman, and it is easier with these women than with most to have a platonic relationship. Especially when they are photographed not as available, willing and co-operative partners in love or lust, but as creatures populating a beautiful background and adorning it more as objects of courtly imaginings than actual activity in a haystack or on a hearthrug, or even a marital bed.

And then of course, there is that effortless, casual air the pictures have. This is not a collection of big-breasted, full-throated birds thrusting out their biggest and best bits whilst being showered and soaped inside their transparent macs, nor yet of oiled Venuses draped on the bonnets of big trucks whilst an LA sunset blasts them with light the colour and texture of new-spilled blood.

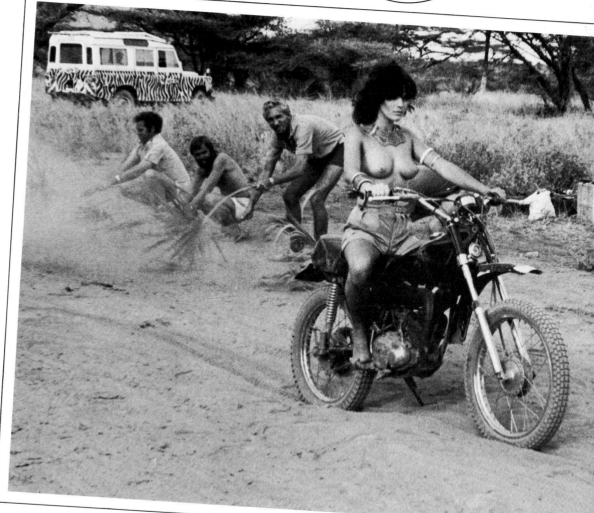

15 Zero degrees on the map but the temperatures often meant the girls gradually turned a darker shade of pale through the shoot; right: Jackie sits in for a test shot, while some of the team beat up the bike's 'dustcloud'.

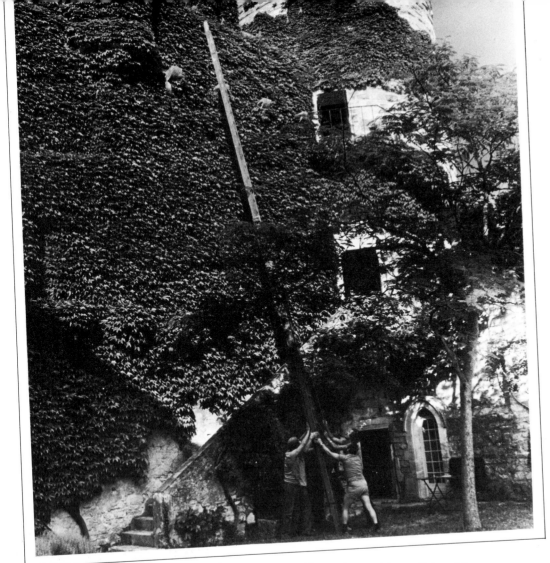

'For the first three Calendars we went for a very natural, romantic look,' says Lichfield. 'I like backlighting, which gives skin a lovely glowing effect.' The first, French, pictures were deliberately made soft, with filters. The Carolina pictures were as innocently out-of-doors as can be imagined. The Kenya pictures were photographed in a mostly torrid, baked light in which the girls seem to shimmer out of the sand and desert. Even the Sicily snaps managed to look natural: if they carry an air of debauch and sin, it is sin done in the afternoon and sober; not, somehow, by artificial light, in dead of night, by drunken boors. Certainly, no artificial light was used.

'In the kind of places we go to, we can't shoot pictures in the middle of the day, usually. The sun climbs too high in the sky. So we work very early in the morning, and then again late in the afternoon. And then you have the problem of the girls sunbathing in between, and the Calendar getting progressively darker and darker as the days go by. Now I'm inclined to send them somewhere to get them cooked in advance,' says Lichfield.

Above all, the Calendar is a piece of wish-fulfilment. It is, at least in part, a kind of travelogue of the fantasies, a trip through an inner mind which has been fed on brochures of the exotic and dreams of the ideal.

Nothing of the sweat of the thing must ever, ever show.

The girls were spirited into these magicked environs, with the bits of thirties lace and their nail varnish and their perfect salon hair and the total absence of anything like the necessaries for life.

Lichfield sometimes rather regrets this: 'Here, for example, it does seem a pity that we don't realize the girl is actually stuck up, rather precariously, in the window of a turret.' Still, of course the effort must not show: 'We had the fire brigade there to help, with their ladders and so on. There was a fireman crouched in the turret, out of sight, to hang on to the girl, who was very brave about the thole thing. And then we had just two captive doves – and a few residents whom we couldn't control, of course – to get the shot with.' Lichfield is describing the very first Calendar shot he ever took, of Karen, then Miss Australia. She could be sitting in an ivy-clad bungalow for all the world knows.

Other shots are less contrived: for one French favourite, a horse-riding owner of a lavender field was (quite easily) persuaded to tie his horse to a tree and hang around to watch proceedings.

And some, to Lichfield's regret, break rules which aren't of his making. He still mourns the yellow-bathed leg of Suzi, which stretched, as only Suzi's leg can, from here to eternity and back again, in the dawn light of the Sicilian castle. 'But they wouldn't have it. They elbowed it because there was no eye contact.'

Apparently, the client, the man at Unipart, believes that girls must always be making with the eyes. And it may also be that in that shot there wasn't the required quotient of well-lit bosom, which even in this bastion of the tasteful and decent must discreetly, even innocently, be on display.

But then the pursuit of perfection is an odd lark. And one which almost certainly will see Lichfield making a few more annual excursions.

Top left: an enthusiastic French fire brigade ready to help Karen to her tower room; right: Patrick with stylist Annie Calvas Blanchon discussing props in South Carolina: none of the effort behind the shots must ever show.

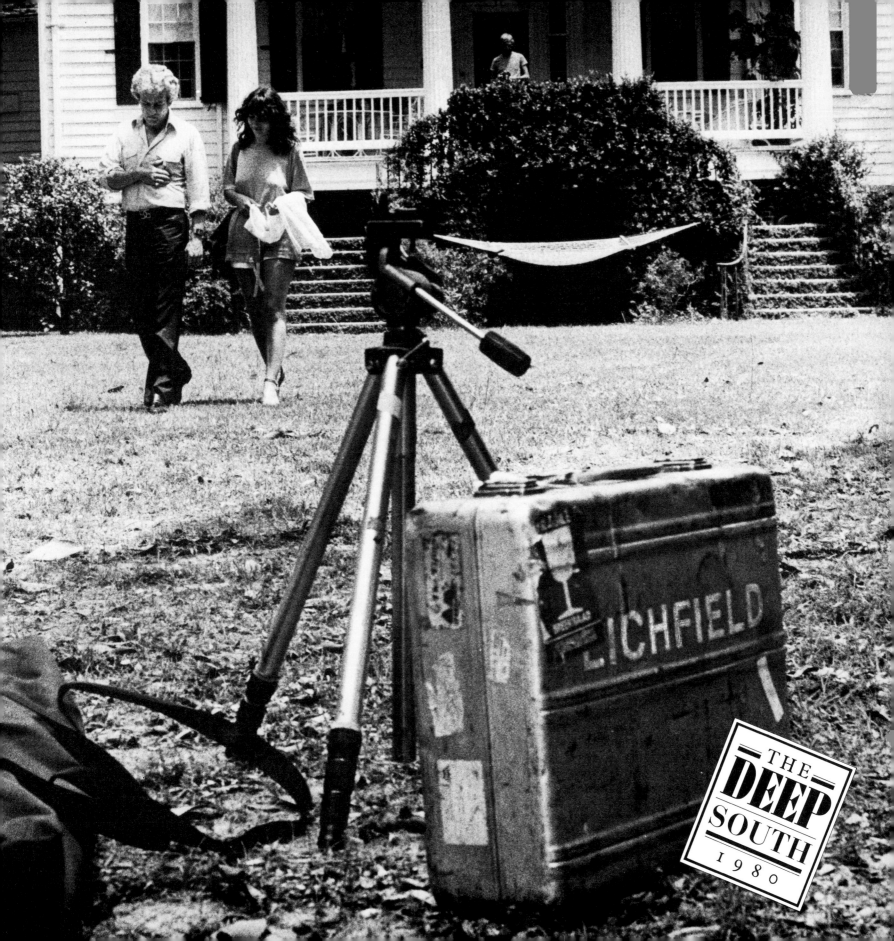

THE
DEEP
SOUTH
1980

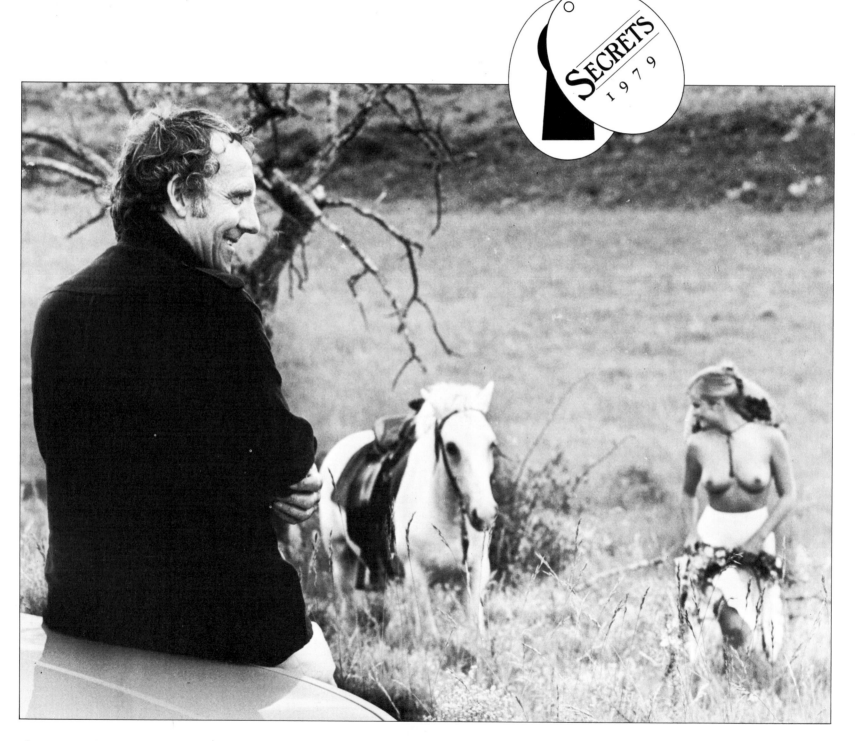

SECRETS
1979

2. THE ART DIRECTOR Noel Myers

Noel Myers is what used to be called a rough diamond. He is as well-built as a man who is adept at wine _and_ tennis should be. He talks rough and does it in a voice which has been gone over with the coarsest wet-and-dry and then sand-blasted into the bargain. He is actually rather a kindly fellow and given to thinking of others.

But you wouldn't always know it. He and Lichfield usually have a few rows when their ways differ on the shoot. Sometimes they actually fight, and Lichfield tells a funny story about Myers bloodying the lordly eye in one altercation that got out of hand. 'I was mostly worried it might be the – camera's eye,' he says.

But then, Noel Myers doesn't just add the art direction to the Unipart snaps. He also is a major contributor of aggression, the man who has made it a peculiar part-time profession to make beautiful girls look sexy with it. Amazing how easy it is for even a very beautiful girl to look like most other decorative girls: Lichfield says it is often Myers who can make them sit up and transmogrify themselves into the stuff that dreams are made of.

Pursuing his speciality, Myers has worked with most of the big names in glamour photography.

'Patrick didn't know a lot about this sort of glamour when we started,' he says, as we sit in his creative shoebox in an advertizing agency where normally he is chicken-cooped with a writer for company whilst planning how to flog us yet more strides, soft drinks and matching kitchen units. 'What I

particularly like about his pictures – and it's really not an easy quality to get hold of – is his innocence. His pictures are fresh.'

It was easy enough for this quality to be to the fore for the first three Lichfield Calendars: but by last year everyone on the team was ready for a change. It emerged that what they wanted to do was to inject some quality or other into it which came to be called 'hardness'. Oddly, and it says something for Lichfield's innocence of eye, the result remains more theatrical and suggestive than frankly sinister.

For Noel Myers, the trips with Lichfield represent a sort of crazy break from the strict commerciality of his workaday art. 'We've got a much freer hand than we would have on a commercials shoot.'

It is still his job to come up with a scheme which can be sold to the client who must stump up the thousands of pounds which finances the fortnight in faraway places the Calendar always represents. The

Each Calendar has a theme and it's versatile Noel Myers' job not just to come up with the ideas but to unify the whole shoot: in France he grabs a passing pony to add the necessary _je ne sais quoi_ to Denise and in Kenya (right) explains a prop and a pose to Melissa.

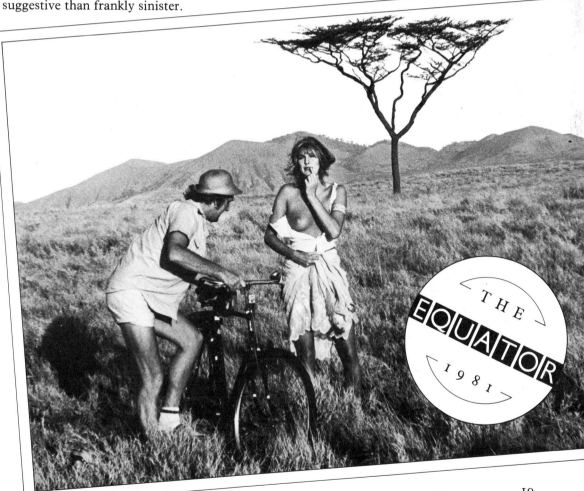

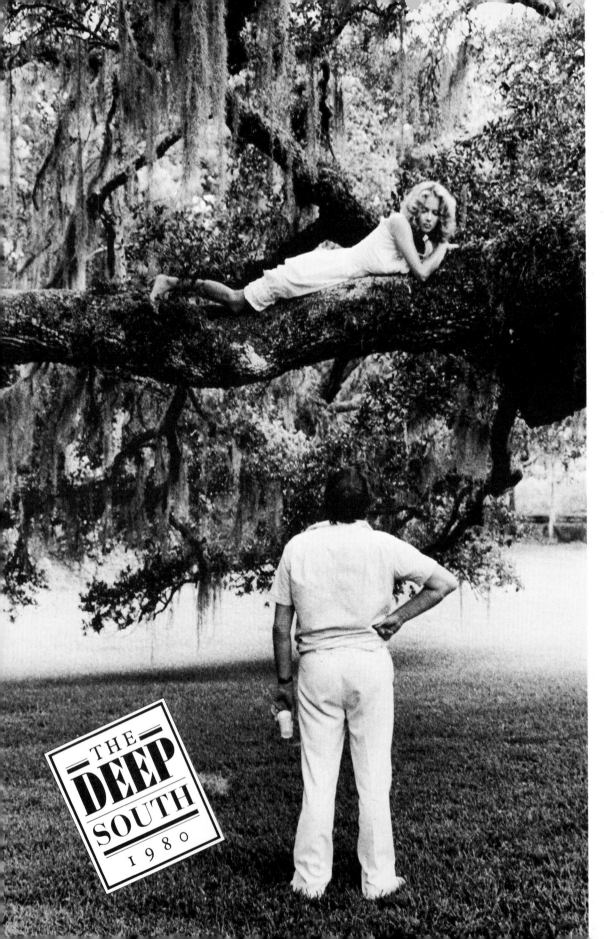

THE DEEP SOUTH 1980

winter months blow their gales over London, and Noel and Lichfield and Annie and the others meet up periodically to speculate on what might make a reasonable theme.

Up till March this year there have been three competing ideas rattling around the Myers conceptualizing department. He has brooded on the idea of Grand Hotels as a venue. But then – prompted by Annie – they began to get excited about the prospect of Art Deco, or was it *fin de siècle* or perhaps Pre-Raphaelite? All that's very well, but suddenly, out of nowhere, the notion of the eastern seaboard of the States turned up in someone's mind. Aubrey Beardsley in Cape Cod? Can Noel Myers quite *see* that? Will the client?

Only one thing is even remotely certain. Noel and Patrick will make their same old odd, admiring team. There will be the same rows going on: Noel's side conducted in something which might be called Cockney in defiance of its having been cooked up well south of the River Thames in Forest Hill; Patrick Lichfield's in the Guard's officer voice that he grew at the same moment that his voice broke.

And half way through the shoot, according to Lichfield, Noel Myers will up anchor and drift off to his room or tent with the polaroids-so-far and brood. And after this three or four hours of doing an Achilles number, he will emerge and pronounce. It seems that this is the moment when they've still got time to redo the shots to make them a better-mixed package, or when they can go on as before, but with a greater sense that they've done the business.

And thus by a process which has something of the mollycoddler and a good deal of the bully boy, all laced with a very agreeable volubility, the art director earns his grand name.

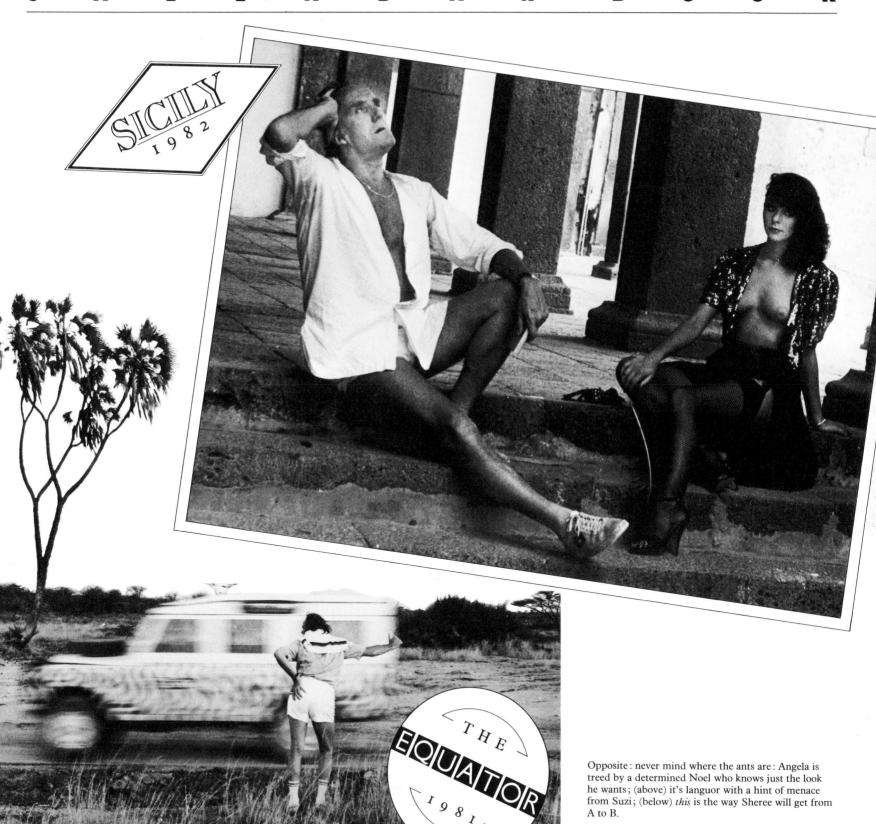

SICILY
1982

THE
EQUATOR
1981

Opposite: never mind where the ants are: Angela is treed by a determined Noel who knows just the look he wants; (above) it's languor with a hint of menace from Suzi; (below) *this* is the way Sheree will get from A to B.

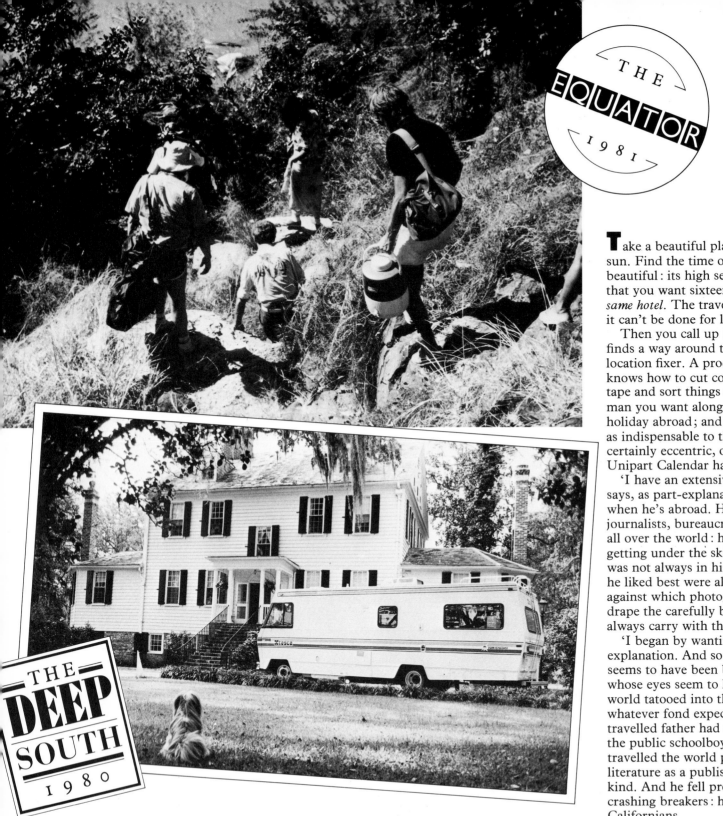

THE DEEP SOUTH 1980

Every location has its drawbacks and difficulties: rough country to cross at Chandlers Falls (top); seclusion to be sought in Carolina (above); and a balance of grandeur and decay in Sicily. Sebastian Keep (top right) takes his own shots of possibles to discuss with Noel.

Take a beautiful place. Drench it in sun. Find the time of year when it's most beautiful: its high season, say. Then insist that you want sixteen bedrooms *all in the same hotel*. The travel agent flips, and says it can't be done for love nor money.

Then you call up Sebastian Keep, and he finds a way around the problem. He is a location fixer. A production man. He knows how to cut corners, annihilate red tape and sort things out. He is the kind of man you want along when you have a holiday abroad; and increasingly he is seen as indispensable to the rather large, and certainly eccentric, operation that the Unipart Calendar has become.

'I have an extensive address book,' he says, as part-explanation of how he operates when he's abroad. He knows diplomats and journalists, bureaucrats and informed bums all over the world: he cultivates the art of getting under the skin of far-flung spots. It was not always in his mind that the places he liked best were also the sort of places against which photographers would like to drape the carefully bronzed models they always carry with them.

'I began by wanting to go surfing,' is his explanation. And so this man, whose tan seems to have been blitzed into him and whose eyes seem to have the scenery of the world tatooed into them, dropped out of whatever fond expectations his well-travelled father had of him. Sebastian was the public schoolboy son of a man who travelled the world peddling English literature as a publisher's rep of the classiest kind. And he fell prey to the call of crashing breakers: he out-Beach-Boyed the Californians.

He has surfed in Peru, Mexico, California, South Africa and France. 'Through that I got to know an awful lot of places,' he says. He is modest, this blond

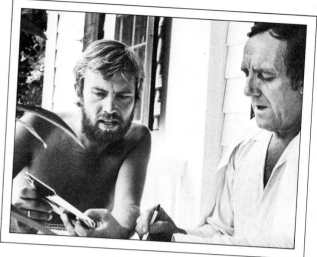

3. THE FIXER Sebastian Keep

hunk who is safely and decently married with children and who listens to Bach on the stereo between jobs.

He is also no mean photographer. Which means that he can show prospective clients a massive range of sites and spots which he has visited, and can tell them the difficulties they will need to anticipate in each of them.

With the Unipart job, he knew early on that the southern States project for the Calendar, which would delineate 1982 for the favoured greasers who saw it, would be no easy number. 'Extreme heat, humidity and mosquitoes,' he told the crew. So he was sent off to find somewhere suitable which would be hot, sunny and lovely, but would not have the full rigours of high Miami.

South Carolina was the choice. However, it was not only the climatic considerations that applied. America is not all Sunset Strip and Broadway: it is also the greatest

repository of reaction this side of the Urals. 'They were very straight about things like nudity,' recalls Sebastian, and it was not the kind of news which much amused the Calendar lads, for whom it was a *sine qua non* that the girls must put a good deal of themselves on show. 'And it's no good at all having them hanging around in great macs and then getting them to flash for the camera when no one's looking,' says Lichfield.

So Sebastian had to find a place deep in the South which was hot but not too hot, and which had traditional architecture but which miraculously avoided having traditional attitudes. He found the kind of person that the Sebastian Keeps of this world must be able to detect and court at fifty paces without fail.

She was an emigrée Russian of grand lineage. She owned the required ante bellum house and she had a mind as broad

as the plains of Georgia. Girls could desport on her lawn from dawn to dusk in whatever, and however little, was deemed fetching She could provide what the crew wanted: privacy, good lunches, exotic scenery.

And when Lichfield got Sebastian to ring and book tables for dinner in Charleston (and Sebastian fixes the smaller things as well as the larger, is a kind of valet of the psyche when needed) it was Sebastian who found a way of putting the record straight when the restauranteur, no more versed in music than in Debrett's, thought that Earl Lichfield must be some old piano player come back from the grave.

But Sebastian Keep's life is, he insists, rather far from being all jokes and glamour (but then everyone in the glamour business tells you that). 'You arrive in a city in the middle of the night. You're jet-lagged and alone and you've got to sort something out.' It is as though someone had made a profession of taking the shock out of culture shock.

He has found Lord Nelson's holiday home on Sicily for the Calendar, and has turned Kenya into a manageable backyard for the Calendar. As this is written, everyone is relying on him (a) to get back from Cairo and (b) come up with somewhere (and Lichfield says it ought to be between Bali and Bel Air) for the next Calendar.

And when he's found it, he must book the required rooms, sort out the travel and make sure that someone remembers to pack the suntan oil.

SICILY 1982

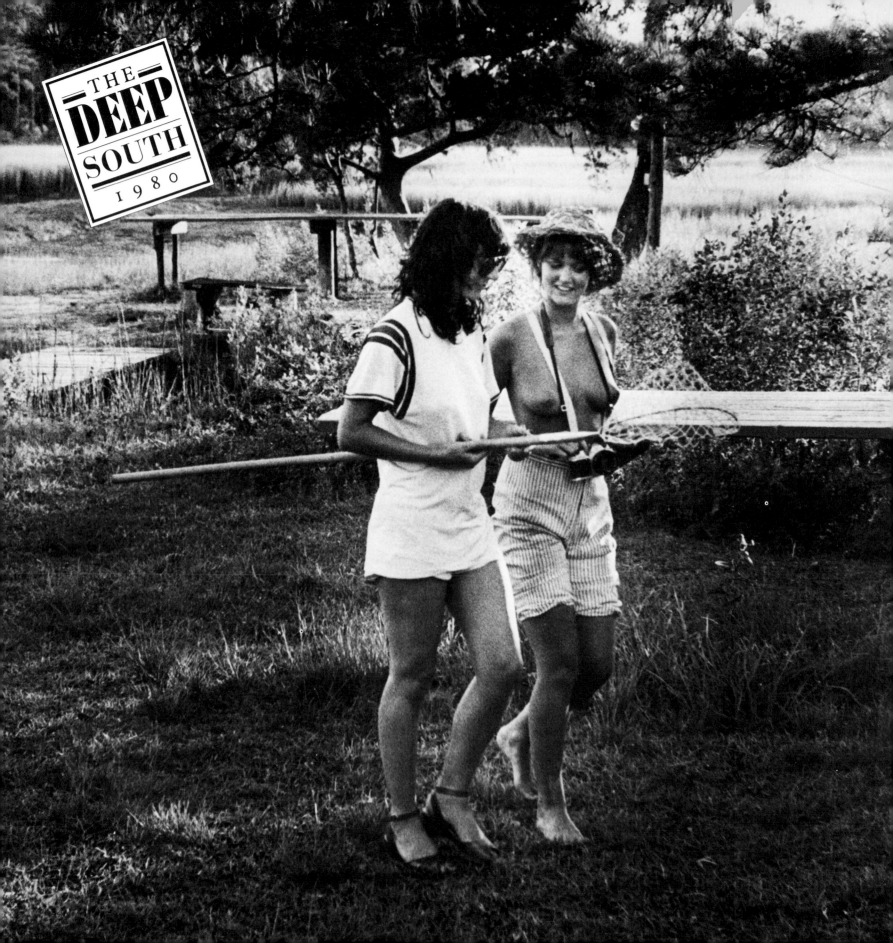

THE DEEP SOUTH 1980

4. THE STYLIST Annie Calvas Blanchon

Annie Calvas-Blanchon is the only woman behind the camera in the Calendar enterprise. She is therefore sometimes drawn into a kind of weird solidarity with the models when the chaps let their hair down and allow just ever so little, just a touch, of the *sexist* into their talk, whilst they pin glamour to celluloid like butterfly collectors with pins.

Boys will be boys, and it can get Annie down.

Otherwise, she is very good at fitting in with the gang – the very various gang – which mobs together to produce the Unipart sheets. She was born on the French riviera, is a stunner herself, and her life in England sounds like one long shopping expedition.

'I've a good eye for looking around,' she says. And a good nose for a bargain, or even a good scrounge. The bike in the Kenya shots – the missionary bike which lent innocence and decency and sturdy reality, an element of Rudge and Sturmey Archer – that was sort of borrowed from a real missionary. They had his umbrella, too, and that made the equator very present as the thing cast a shadow no bigger than itself, a shadow which fell dead at the model's feet, just as a motor mechanic might half hope to.

Or the butterfly – dead – which Spot is admiring in the Carolina shot which shows her perfect chin, as refined as castor sugar.

'We found it in a glass case in the house,' says Annie, who could spot an opportunity at a thousand paces and still bargain with it. ('I prefer bargaining abroad to doing it in England,' she confides, with proper understanding that as a nation we take no real pleasure in the sort of street theatre of meanness with which the nationals of hot countries waste their lives away.)

There is clearly a bond between such people. In Charleston, Annie found herself closeted in a run-down shop with a man who had been Mickey Rooney's stand-in and is now proudly running a prop-shop and antiquery; together they could cook up schemes to make sure that wherever the Unipart gang fetched up, *Gone With The Wind* could be rustled up out of the back of the motor-caravan which toted the gear. This is her skill, as a set-dresser: to leave artifacts and objets d'art like clues in a pictorial detective trail.

It is a skill which takes the humdrum environment in which a photographer finds himself and makes it look not merely perfect, but the perfect example of whatever they're after.

But it is clothes in which Annie is the real mistress of the wardrobe. She has

THE
EQUATOR
1981

The 'hidden' extras in every shot are Annie Calvas Blanchon's brainwaves – a Huckleberry hat just sufficiently battered for Spot or (above) a canvas bath in Kenya, with Annie proving dextrous with a borrowed iron for a last-minute finishing touch.

THE
DEEP
SOUTH
1 9 8 0

friends with shops with names like Echo, and Essenses. And even knows her way round an outfit called Trashy Lingerie. The Fulham Road and the farther reaches of the King's Road all yield up corsets and diaphanous bits and old frocks and trinkets and baubles for her. If they don't, or she's in a hurry, she whips round to chums and gets them to give up their very suspenders, the underwear off their backs, for the cause of the Calendar.

And if things are more leisurely, she rings up Berman's in Camden Town, a place where every age and period and condition and type of man and woman the world over have had their clothes mimicked and replicated, and where Annie browses like a bibliophile in the Charing Cross Road or an entomologist in an Ecuadorian jungle.

The girls in this, the classiest of classy Calendars, get to wear the real McCoy: real Victorian stays etched out the lines of the model Spot's left breast in Carolina, and Ross sits in a real thirties shift whilst she considers whatever depravity it is she is supposed to have escaped from into the penumbral corridor where it just so happens she is able to scowl so perfectly at a strategically placed art director, a photographer, an assistant, and a pleased stylist.

Annie's job is to dream up and secure all the bits and pieces, the gear and the accoutrements, which will create Noel Myers' fantasies. She clothes the nakedness in myth. She puts the fabric, the properness, into the Calendar, the props without which the thing would not be quite so refined a piece of tantalizing.

Like someone preserving the decencies, by draping something here, or covering something there, she adds the mystery and therefore the real naughtiness of the whole thing. Naked tarts thrusting themselves at the lens are everywhere. Some of them do it in comely, comfortable bra and pants for added effect. But it takes the likes of Annie to make minds burn with yearning whilst simultaneously (she's worth her weight in gold, this girl) making the whole enterprise somehow censure-proof.

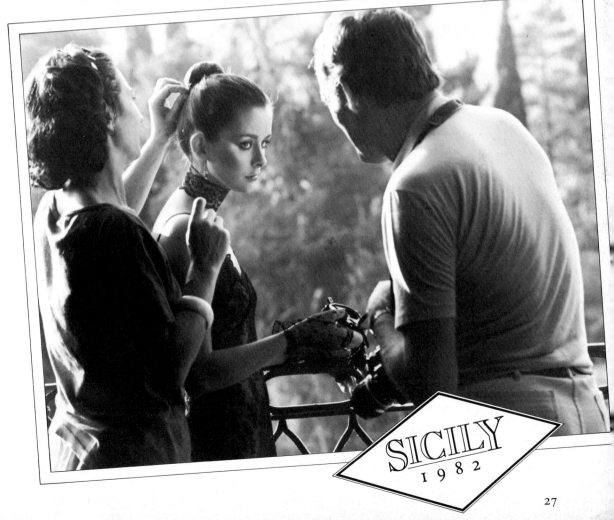

SICILY 1982

A stitch, a glass, a hair – everything has its place and Annie's flair for finding them conjures a picture's mood just as surely as Angela's or Suzi's expression.

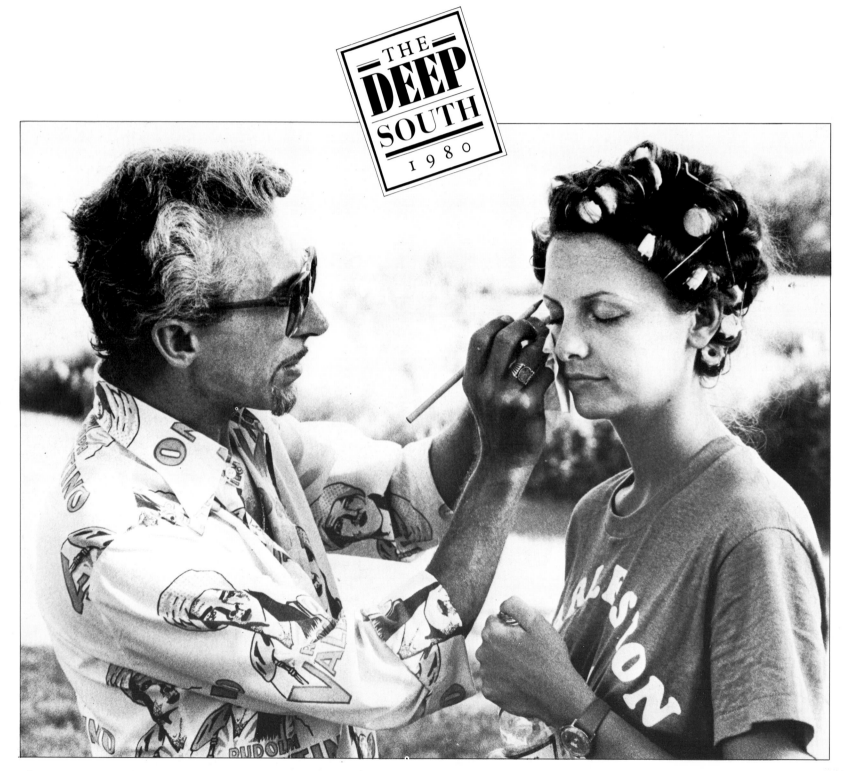

THE
DEEP
SOUTH
1980

5. THE MAKE-UP ARTIST Clayton Howard

Bow down before Clayton Howard. Venerate the name. Walk from the presence backward, to mark respect.

This is the man who made-up the Lady Diana when she was still a not very plain Spencer and was going to be photographed by Snowdon. Hardly less significant: he was the man who gilded the lily when Katie Boyle was photographed by Lichfield for the cover of her autobiography.

And whisper it low: he is the man who makes sure Gary Glitter glitters just right when the singer's in the mood for sparkling freckles and cheek-bones that leap out of the face like cliff ledges cormorants could bring up a brood on.

For the Calendar, his job used to be very difficult in a very particular way. 'Patrick doesn't like a lot of body make-up, and we're not doing conventional glamour shots. So the make-up has to be very sensitive and delicate. It takes far longer.'

Add to that the fact that he is often up at five or six in the morning. In Kenya, there was a make-up *tent*, and for one shot the day started at four am, before dawn, and

by oil lamps. 'Try doing a make-up by lamps, which has got to look good when the sun comes up,' he says.

In South Carolina, the trouble was, if possible, more severe. 'The mosquitoes were so bad, we often had to have a kind of blower which filled the air with smoke. It made the water lilies close up, so we had to use picked flowers. And it covered the girls with white powder.'

These are not the sort of problems which Clayton Howard learned when he switched from window dressing and became a fast-stream trainee at the London salon of Max Factor.

Then he was learning the trade of making beautiful women very beautiful indeed and making not-very-beautiful women into passable imitations of beautiful women. He is a man who has it in his hands to deal out

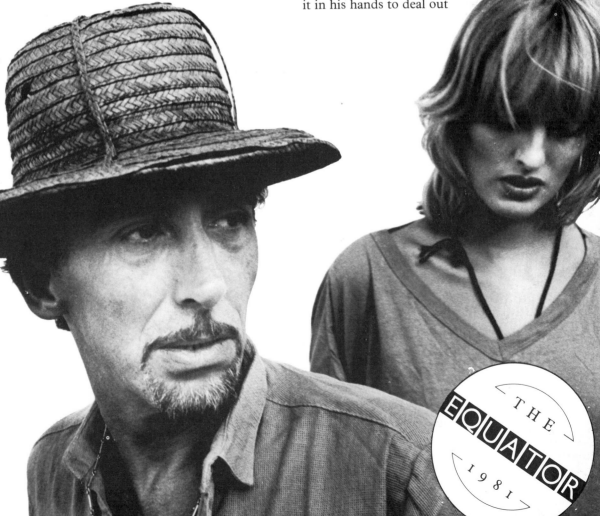

8–9 The man who sees what the camera doesn't: Clayton Howard preparing Lesley-Anne for a Carolina shot and (right) with Melissa on Lake Baringo: disguising mosquito bites became an additional problem on both locations.

THE EQUATOR 1981

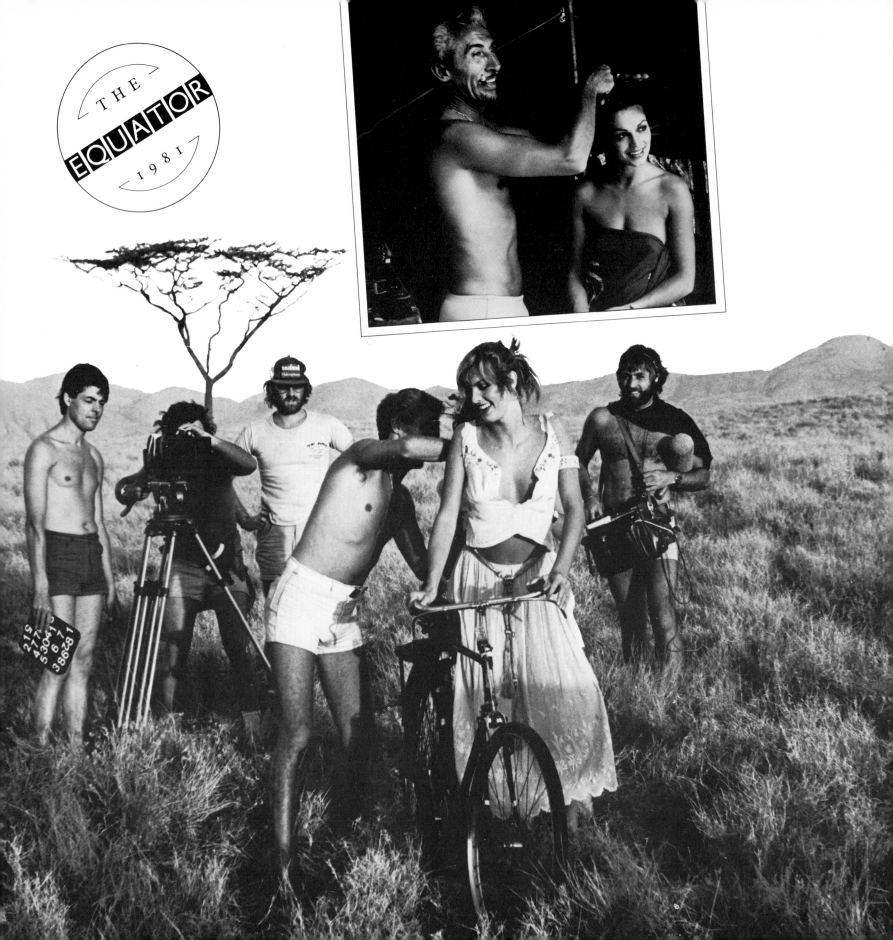

what most women most desire and don't mind – at a push and in a pinch – if it comes out of a jar. He is Merlin the magician and from his fingers fall not stardust but brilliantly meted-out Spunshine Copper and Pink Panache and the odd dollop of Geminesse.

In those days, and still often enough, he was right out of the song:

'You wanna be an actor
Go see Mr Factor
He'll paint your kisser real good
Hooray for Hollywood'

or some such ditty which Mr Howard can lightly trill as, a cigarette holder clamped between his lips he paints, daubs, wipes, touches-in and shades-up faces which before he got to them were just eye-openers. In his care, they become show-stoppers.

In Africa, he had to contrive to make the girls look as though they didn't even know the meaning of make-up, so sun-drenched and natural and just sort of come-up-upon were they. But luckily, his skills didn't all need to be so delicate and understated. He happened on a bunch of tribespeople – Samburu men – who liked him to do them up properly. In – as near as dammit – warpaint.

But for Sicily, he could get out there and really boogey, which was part of Lichfield's plan for the shoot. It pales into

insignificance that he was allowed to get out in front of the camera for once, got up in Lichfield's most operatic bib and tucker, starched and blacked and Astaired to the nines. What counts is that for once he was in the business of theatre make-up: Sicily was the location for dames and whores and tarts and trouble and sinister bits and pieces and left-hand-down goings on. Clayton Howard had recourse to his pots and tubes and mysteries in a bigger way than usual.

Usually, he just can say of his subtle outdoor make-ups: 'Well, *I* know it's a successful make-up, because I know what the girl would have looked like without, say, the make-up which helps the shape of the face to be emphasized. But no one else must see it!' Not so Sicily: 'These were

wilder make-ups, more punky, almost.'

But then, what make-up artist would not prefer a world full of warriors and witches, rather than populations of schoolgirls, with their perfect washed and scrubbed faces which do not need his work? Except perhaps when the youngsters, these visions of perfection, get something so undignified, so annihilating, as a blemish. But the girls on Lichfield's jobs are safe with Clayton. If they have blemishes, he covers them up: anything so unsightly as a pimple is something between two professionals, and he is too kind to admit Lichfield's girls ever even get them. Except when those mozzies do their worst and Clayton is found making whole bumps disappear.

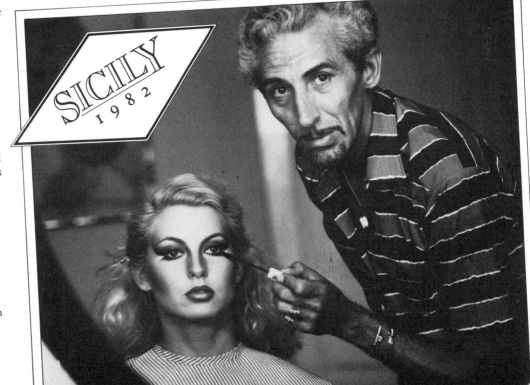

Top left: work with Jackie began at 5.00 a.m. in a tent lit by a hurricane lamp, for outdoor shooting in strong Kenyan sun – as below, watched by a documentary film crew. Right, in more conventional surroundings and more subdued lighting, Ross's make-up for a Sicilian shot is completed.

SICILY 1982

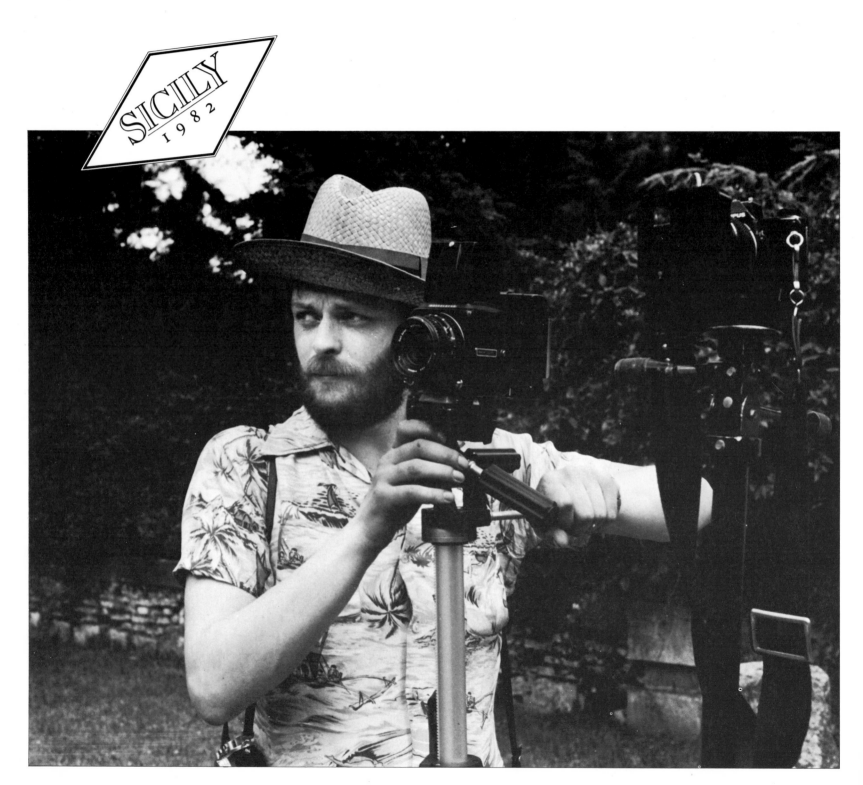

SICILY
1982

6. THE ASSISTANTS Chalky Whyte and Peter Kain

Lichfield's assistants have what might seem a thankless job.

Chalky Whyte went to an art school and learned how to be a photographer: he takes pictures for money. Pete Kain has just come back from Africa where he was taking pictures for a new book by Richard Leakey, the palaeontologist. These are talented people. They also have to put up with playing photographic second string to Lichfield. They accept this role, one guesses, only partly because he can generate the income that keeps them content.

Each of Lichfield's assistants takes time off from the London studio and disappears to pursue his own career: it's a system which allows Lichfield to have brighter and better people around him than would otherwise happen. Providing they make sure between themselves that one of them's around, then that's fine with the boss.

For the Calendar job, Chalky says their role is mostly technical. 'I check the light meter all the time. As time passes on a shot, the sun shifts, for instance: so I'm there thinking about that whilst Patrick's off on his creative bent.' The assistants are also the custodians of the gear: the two (or sometimes four) camera bodies, and the battery of lenses. And the film.

The order that goes into Kodak is no tiddler. Lichfield buys film in dollops of three or four hundred rolls at a time. It lives in a fridge so that it is exactly and

always the same, however long they may keep it. And then, just to be sure they know what's happening, they test a sample from each batch so that they can assess the little

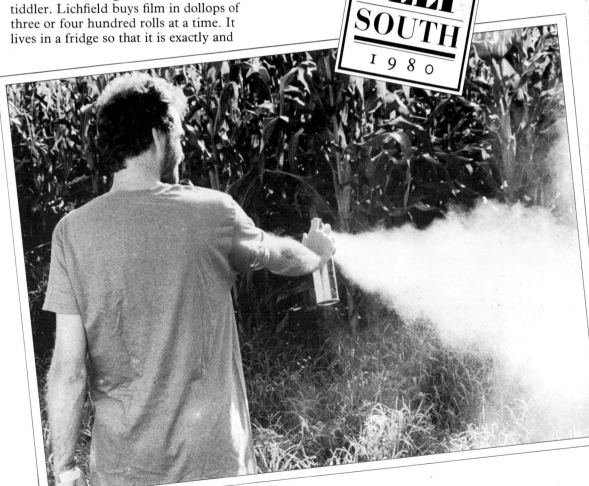

THE DEEP SOUTH 1980

Location work teaches all the angles: in Sicily Chalky Whyte aligns the camera for the group shot and Peter Kain (right), in Carolina, gets to work with mosquito repellent.

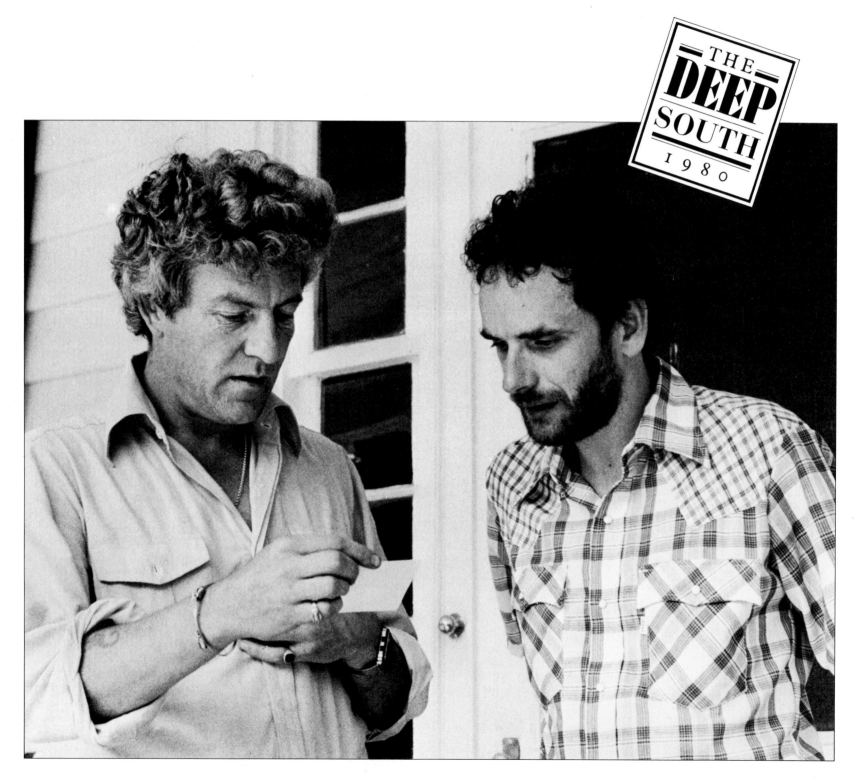

THE
DEEP
SOUTH
1980

ways in which it varies from the absolute standard. 'Kodak maintain very strict control,' says Chalky. But that wouldn't be much of an excuse if the team came back from half way across the world with snaps which were just a little pink for their taste.

Photography is the doubtful business of turning art into a science. Photographers like to be sure they understand the nature of the canvas they are going to work with. Woe betide the assistant who doesn't know all about the hundred rolls of film which are the ultimate raw material of the Calendar.

But perhaps the assistants' greatest role is in their ability to improve on nature. They are the lads who can so hold a brightly-interiored umbrella, or a reflective plank, so just the right amount of light is turned away from its earthward plunge and reflected – all contrary to creation's usual habit – under a girl's breast or under her chin, buttercup-wise. They are masters of artifice: hanging about upon the hour with their bits and pieces, and able to apply tricks and certainty in just such a way that the untoward doesn't happen, and the perfect snap does.

SECRETS 1979

Peter and Patrick discuss polaroid results before committing a shot to final film: checking exposure (as Chalky is doing, right) or adjusting silver reflector sheets to alter the way light bounces, comes naturally to these artificers.

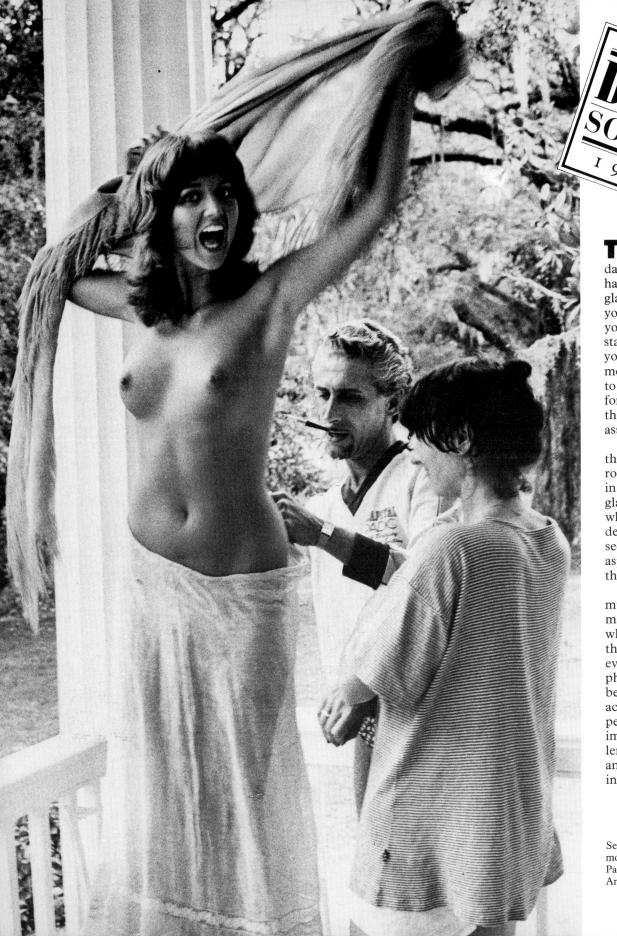

Their faces alter with every different daubing of make-up and every twitch of the hairdresser's comb. They pout, whimper, glare, invite or frost at will. They can melt your toe-nails with yearning and hope if you're a man, or set daunting, awesome standards for envy and intrigued interest if you're a woman. They are old at thirty and mostly too young to be experienced enough to be a good bet at eighteen. They bloom for perhaps ten years in a harvest which they must husband carefully and reap assiduously.

But what is oddest of all about models is that when they parade through the upstairs room at Lichfield's studio – a room which is in steel-grey velvet with tubular this's and glassed that's – they look just like women who are, admittedly, definitely in the top decile of loveliness. But it is reassuring to see that they are not – these thirty or so aspirants – spiking your eyeballs in quite the way they will on paper.

These are girls who have a quality which must transcend altogether the capacity to make your head spin round in the street whilst your girlfriend or wife throws you the exasperated smile of tolerant women everywhere. What these girls need to be is photogenic. They are not, all of them, more beautiful than a painter's model or an actress: but they have some species of perfection which is in love with the implacable convexes of a photographer's lens. They make the glass and the levers and the chemicals and the momentary light in a black box produce magic.

Seldom off the job – Spot quite enjoying having the mosquito bites touched in by Clayton and (right) Patrick explaining shots, from polaroids, to Spot and Angela.

7. THE MODELS Spot and Suzi

Spot – who has since become much better known – was one of the girls who went with Lichfield to Carolina in 1980. She has the immaculate good-looks of the perfectly possessed English girl. She could have sprung from a long line of English vicars, brewing their families in great parsonages in the country. She has the capacity – proven in a string of advertizing assignments – to look reassuring (she has been the young-mum ideal in mortgage ads) and devastatingly fresh (as in some frock-ad designed to tempt women to imitate the composed youthfulness pinned to the page in front of them).

None of this has turned her head. She smiles a lot and makes a friendly hostess over tea in her wendy-house of a Victorian lodge, in a part of town where the surrounding houses dwarf her own as thoroughly as a forest looms over a cottage in a fairy story. She shares it with a husband and the art deco china she collects and with an Old English sheepdog, whose chances of being left on a motorway verge – usually high with Dulux dogs who've outstayed their owners' seriousness of intent – are nil. There is barely room for them all.

She mostly thinks being a model is not a very serious business. 'Well, you're just a clothes horse, aren't you? Just a silly tart who looks good.' The absence of angst is mightily cheering. It's one thing to be paid to be admired for a happy accident of nature: it'd be altogether another to believe one was a Sarah Bernhardt on account of it. Spot doesn't seem at all the kind of girl who would enjoy being so much on display. 'When I first took my clothes off it was for a Lamb's ad, and I can't say I liked it much. Perched on a boat sticking your tits out and all the men on the pier staring at you. But I suppose you get used to it.'

Actually, though, she didn't give herself the chance to become familiar with topless work. The rent and more is paid without taking on that kind of work, for which the appetite soon wanes. Spot knows well enough that she's happier keeping the bits of her which are private, private. She hadn't been working as a model long when the call from the agency came for her to go and test for the Lichfield job. She wasn't that keen and she nearly missed the session. In the end she went.

THE DEEP SOUTH 1980

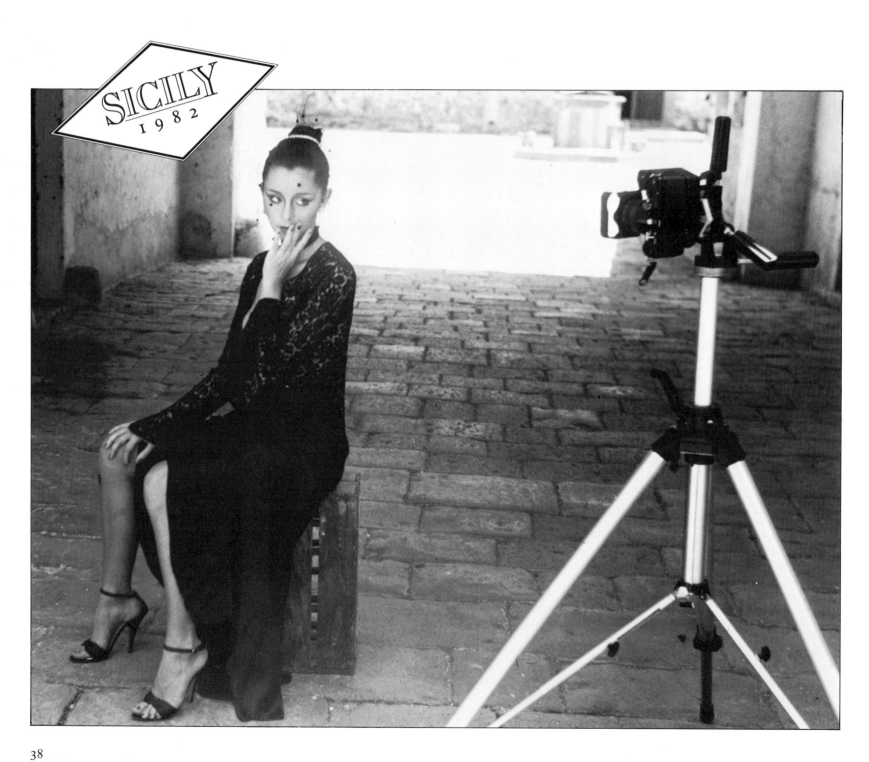

SICILY 1982

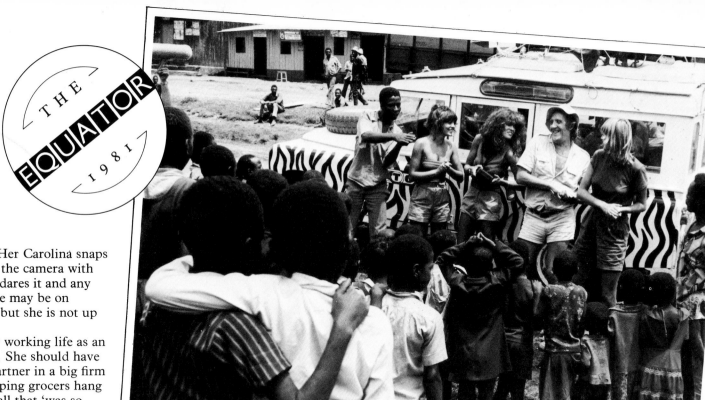

Which is just as well. Her Carolina snaps are superb. She stares at the camera with proper insouciance. She dares it and any male to take liberties. She may be on display, the look asserts, but she is not up for grabs.

Young Spot began her working life as an accountant. A tax officer. She should have gone on and become a partner in a big firm and made her money helping grocers hang on to theirs, except that all that 'was so boring'.

So she left Long Itchington (and yes, she agrees, it does sound a touch dermatological) in Warwickshire. She had been in London a year when the Lichfield offer came up, and it represented the big time.

'This *is* a bloody hard business, and you've got to have all your bits about you if you don't want to end up with your legs akimbo in Fiesta,' which – we've already seen – she didn't fancy one bit.

'And the work is difficult too. It actually is quite frightening to be told to look seductively at a camera. "Smile seductively," they say. Well I can't do that, not to order.'

However she *did* triumph at this Calendar work, and she certainly decided that the best point of it was to be somewhere glorious and to be enjoying it.

Except that there were one or two local difficulties, mostly in the fauna department.

Apart from the knock-out heat, there were the various creatures who wanted to crawl over all that exposed, white, tantalizing skin. Against the depredations of myriad mosquitoes ('Amazing mozzies, they were') the girls were got up in buckets of some repellent oil. Take the picture which whiled away the mechanics' March 1980. A gale of wind, probably, howled through the concrete halls full of bits of Cortina or Marina. But what of exotic Carolina?

'I stood there and was devoured by these horrible little crabs. Black ones, crawling up my legs. And I was up to my ankles in squelchy mud.' For another, equally luxuriously perfect shot, wherein all the world is orderly and fine, and some absurdly demure, fantastic supposed plantation girl has just happened to find herself half-naked on some arboured steps – well, for that one it was ants which assaulted her.

And nature isn't all that nature might be in these Calendar snaps: there is nothing natural – not even anything very much probable – about these veiled semi-clothed girls, looking for all the world like the denizens of some fancy brothel who've been asked to a 'Come-As-You-Are' picnic. Or is it more that they look like girls who've just been let out of Roedean or Benenden and rocketed straight round to a theatrical costumiers, and *then* got caught altogethering it?

Sweet Spot should worry, either way. She looks round her pretty house, nudges the great dozing dog and says, 'I've collected most of the stuff in here and done up the place out of what I've earned from modelling.' And now she does classier and classier work, and gets to keep her clothes on.

Suzi from Liverpool has further to go than Spot in the business of cashing in her spectacular looks for quantities of what makes the world go round.

She is a small girl. What a caption-writer might call 'petite'. 'Too short to be a real fashion model,' she says, with the honesty which she always spreads around with the fervour of one who might be up in front of St Peter any moment. She is small and perfect.

She treks about with a giant portfolio to show clients at the casting sessions she attends, hardly realizing what job might result from each; just as she didn't know what might come out of the visit she made to Lichfield's place, and which led to her being one of three girls who went to Sicily.

'The agency called up and said it was a Lichfield casting. I didn't know who Lichfield was. I s'ppose I might've if they'd

Opposite: Suzi communing with the camera and (above) a change of role for Noel and the models in Kenya, entertaining the locals while the Land Rover was repaired.

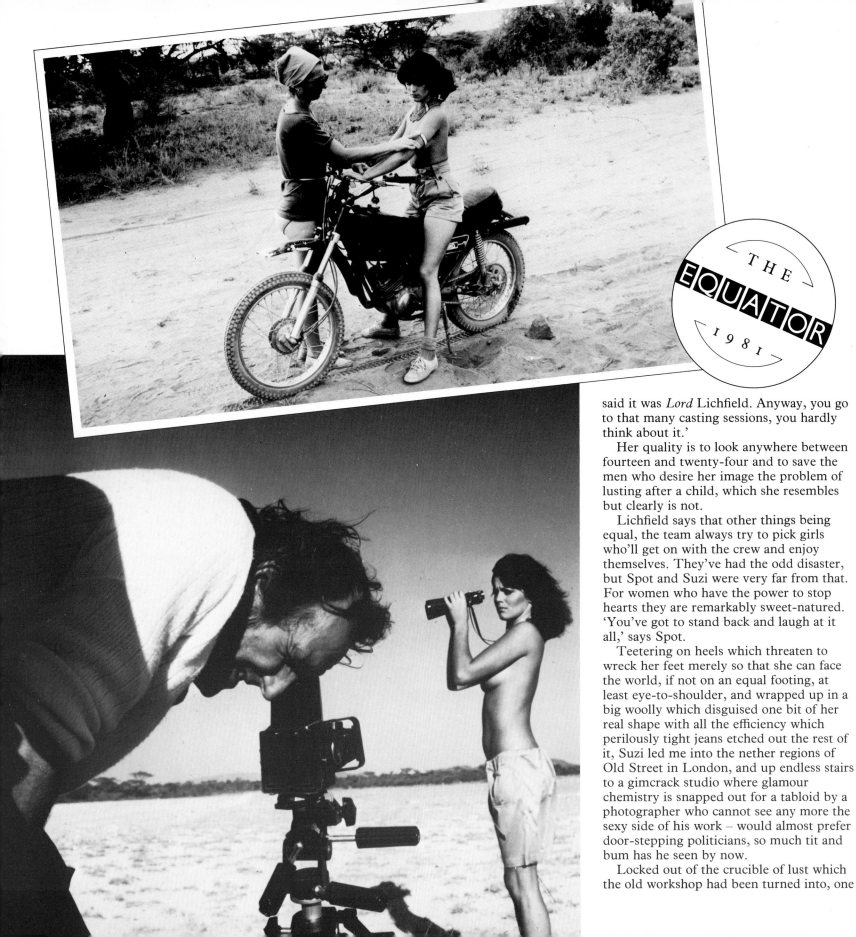

said it was *Lord* Lichfield. Anyway, you go to that many casting sessions, you hardly think about it.'

Her quality is to look anywhere between fourteen and twenty-four and to save the men who desire her image the problem of lusting after a child, which she resembles but clearly is not.

Lichfield says that other things being equal, the team always try to pick girls who'll get on with the crew and enjoy themselves. They've had the odd disaster, but Spot and Suzi were very far from that. For women who have the power to stop hearts they are remarkably sweet-natured. 'You've got to stand back and laugh at it all,' says Spot.

Teetering on heels which threaten to wreck her feet merely so that she can face the world, if not on an equal footing, at least eye-to-shoulder, and wrapped up in a big woolly which disguised one bit of her real shape with all the efficiency which perilously tight jeans etched out the rest of it, Suzi led me into the nether regions of Old Street in London, and up endless stairs to a gimcrack studio where glamour chemistry is snapped out for a tabloid by a photographer who cannot see any more the sexy side of his work – would almost prefer door-stepping politicians, so much tit and bum has he seen by now.

Locked out of the crucible of lust which the old workshop had been turned into, one

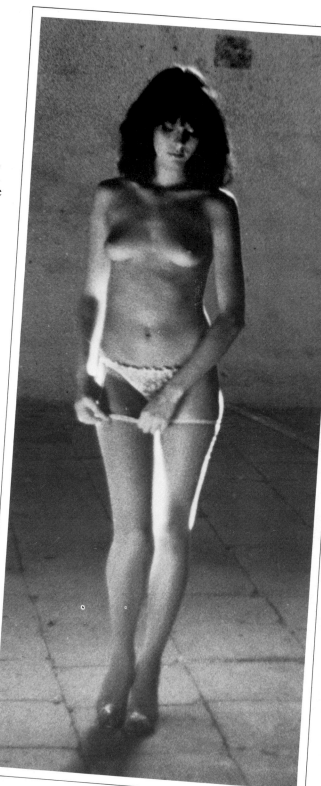

flicked through the great heaps of models' cards with which the desk is littered. Girls by the sheaf; simply acres of glamour, stacked, filed and annotated. Always the same, too: slim, pert-breasted, straight-legged. Female bodies as innocent as (and preferably drenched in) baby oil. Lovely, functionless, funful flesh.

And then Suzi's finished. Another slip signed, which will earn her and her agency another £80 or so. She knows no-one minds anymore: her parents, like Spot's, have got used to seeing more of their daughter in public than they ever dreamed. Quite proud of it, probably.

As for herself, she wants the classy work and will get it. In the meantime, she already has enough cash stacked away to move to London.

And that's after only a couple of years of whizzing down from what has been her Manchester base up till now. No delusions of grandeur afflict her, and she piles up her ackers like a pro: 'I always get the special cheap day return fare,' she says, proudly. A quick mid-day scamper to the Smoke, a session in a studio and back, mostly in decent anonymity, since it's her dynamic sylph's form which is so well known, rather than her face.

She's a born model. Clayton Howard can turn her into a Kate Bush look-alike, or she can come on like a compressed, energized version of Dallas's poor, bouncy, labotomized Pam Ewing. In whatever role, she has, definitely, got what Spot calls a model's 'bits' about her.

Lichfield tells anyone who'll listen that she's extraordinary. She was ideal for the trapped, tortured, sequestered and lingeried Lolita figure in the Sicily venture, brooded over by the 'older' figure of a gaoler, mother, lover or music teacher.

She may have seen a good deal of the

world (and she's been modelling practically wherever the sun brings the palm trees out), and the world has certainly seen a lot of her. Still, I half expected to get turned out of the bar we ventured into to talk. When Suzi – who'll be a star model, and clothed, too, before she's finished – ordered a drink, one felt very nearly compelled to tell her of the dangers of hard liquor. Money can't buy her look of innocence. It just floors you.

But then, beauty makes fools of us all. Except, perhaps, of those who have it.

The girls patiently work through endless preparations: (opposite) Annie adjusts Jackie's accessories and Noel sizes up a shot of her. Right: Suzi rehearses position and pose for the yellow stocking shot (on the book's cover).

8. THE CLIENT Keith Russell

Usually, a client is just the fellow that pays the bills. But here is one that takes the thing a shade further. This is The Client: the piper who insists on his right to call the tune.

Keith Russell knows about that spectacularly twentieth-century trade, PR. When we see, in a TV movie which promotes the Calendar for nearly an hour on prime time and for which Unipart pays not a sou, a helicopter which whisks the burly and sweet-natured art director, Noel Myers, into a conference in some noise-ridden motor-racing circuit, that is Keith's triumph.

But the helicopter only *bears* the name UNIPART, just as do half the Calendar crew that year who wore UNIPART on their T-shirts. Keith Russell didn't own that helicopter. The whole of Unipart don't own a helicopter. But he knows how to rent one, and knows how to make sure that when they do it wears UNIPART big and bold, if possible in luminous lettering.

But Russell is the thinking PR as well. For instance, Unipart's Calendar, contrary to silly newspaper stories, is not a question of belted Earls and unbelted girls out to please the garage hands.

Actually, Unipart makes money for the nation – proving that selling bits of cars is better than selling whole cars – and within that plus-equation, the Calendar helps Unipart make money.

The Calendar's making is an extraordinary time for the people who make it, when some of them do the most creative work of their year. The result also goes down a storm with the dealers who pay a fiver a time to buy the thing, and whose accumulated fivers contribute to the Calendar's grossing more than the £100,000 that Keith Russell is prepared to admit it costs.

But PR is about some intangible quality which does, yes, it really does, go beyond mere money. Dashing Keith Russell knows that he is peddling small bits of cars and doing it via peddling dreams. 'I really do think the Calendar has to do better than just exploit the "Happy Accident" whereby a photographer and some girls find themselves somewhere beautiful and take some pictures. I want there to be a theme.'

And he keeps the lads on their toes in quest of it: this year's Calendar won't be in Cape Cod, and it won't be about Art Noveau as people were saying in January and February. Young Keith Russell has other thoughts.

He's heard about a school for conservationists on an island in the lagoon that Venice stares out over. And so he fancies exploring a *really* new and tasteful ballgame all to do with filligrees and scrolls and burnished gates and cornices. When he told me all about it I sort of understood, and I was definitely intrigued.

Keith Russell sold me on the scheme for 1983. I'd be surprised if he didn't sell it to you and all those dealers too.

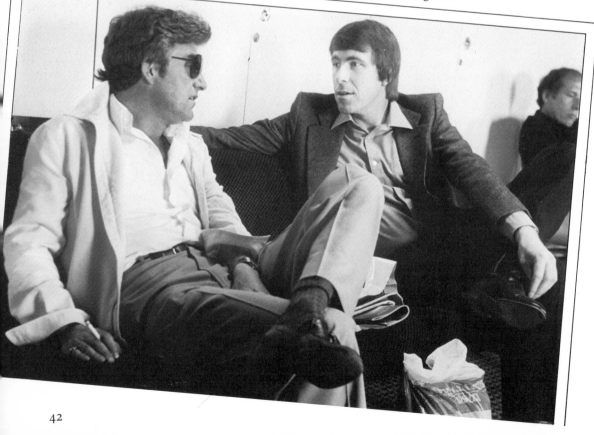

Patrick and Keith Russell checking plans at Heathrow before going to Sicily and (right) Keith's creative trio – Annie, Noel and Patrick – checking a shot soon after arriving there.

9. THE PUNTER Mike

This man, alone of our motley crew, must be nameless. Who wants to be caught in chilly black and white lusting after some little strumpet neither he nor his agreeable wife and all those babes knows anything about?

Besides, the Unipart stores manager I found – somewhere between the Thames and the Wash, and somewhere between Greenwich Mean and the granite of Land's End – was too cool a dude to be fooled by the elegant ploys of the PRs.

'They're trying to get inside your mind,' he says, of all that 'Unipart Is The Greatest' stuff which he gets at the conferences and road shows and stunts that smart Keith Russell gets him along to. He says he and all the others manage to peck a Calendar girl on the cheek and to take a snap of the event back with them.

The knack behind the Calendar, says Mike, is that they've got a way of putting girls on the walls of places where other girls will see them and not mind too much. He doesn't think it's got much to do with wives and girlfriends, this politeness and decency the Lichfield Calendar manages: rather that the secretaries and – for all I know – high-flying female sales executives throughout the motor trade are not daily confronted with something too rude.

His customers prize the Calendar greatly. One made off with the office's copy, leaving the lads at that particular Unipart depot lusting, belatedly, over equatorial girls who have to do double duty seducing jaded appetites through 1982 as well as through their proper station, 1981. The Keith Russell dictum that it's best to sell whatever it is that if you couldn't sell you'd end up giving away anyway is powerfully borne out: Mike is on the high street meting out the Calendar and making other people feel good simply to be on the

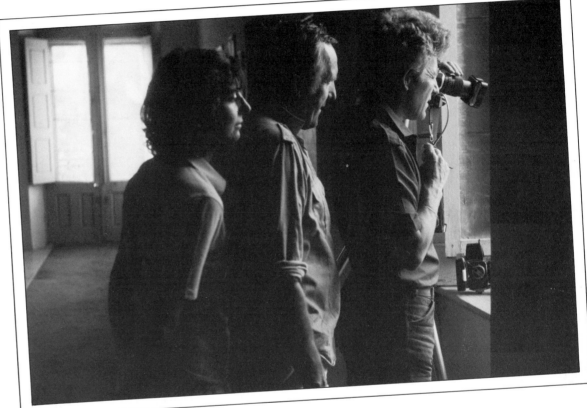

receiving end of such largesse.

And what does he think of the girls themselves? What is the allure of the thing?

'Well,' he says, sipping a lunchtime light ale, 'I wouldn't mind jumping into bed with one of them.'

Oddly enough, I don't altogether believe him: I've the feeling that if he bumped into one of these terrifically beautiful girls he would behave like anyone else: he would distinguish between the girl as an image and the girl as a person. I've an idea that likeable Mike would quickly stop seeing the model as targettable girl, and start getting on with her *qua* person. And after *that*, who knows . . .

SICILY 1982

The team went to France for the 1979
Calendar (with make-up done, this time,
by Lindy Shaw). The shot in the turret:
Karen, with a fireman hidden behind her
and a fireman's ladder hidden in front, is,
just by happen-chance, liberating a dove
from its ivy-strangled home.

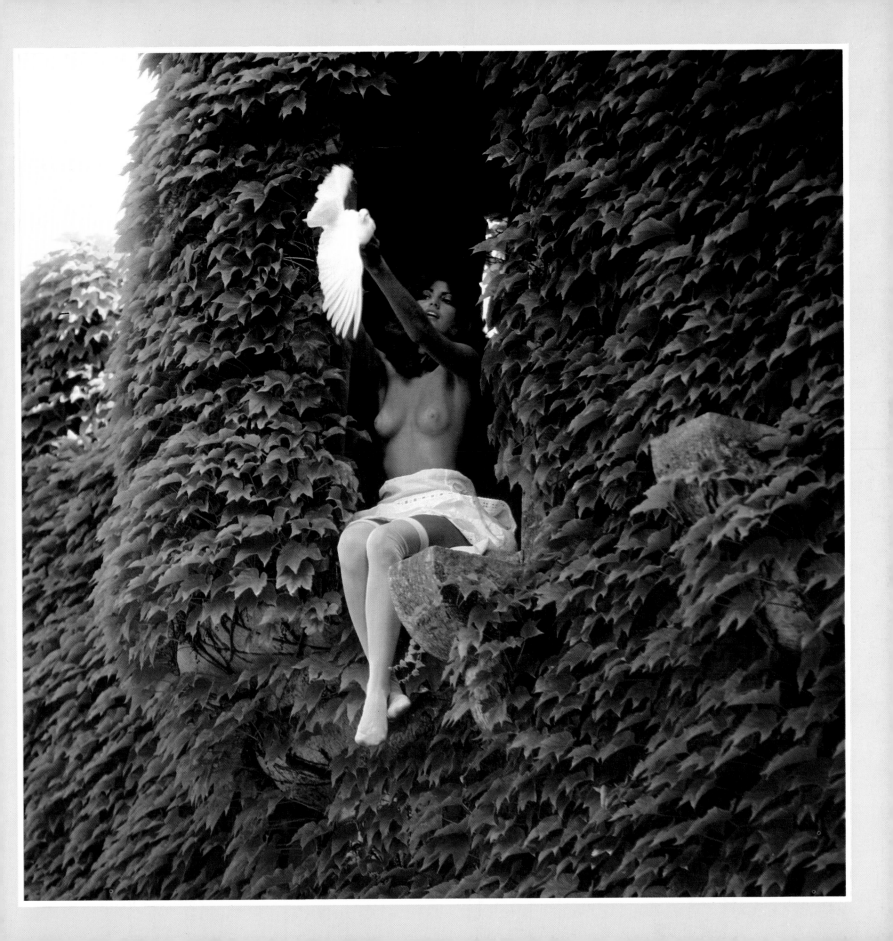

The French Calendar was deliberately very soft and lyrical in tone. Denise, wandering from adjacent lavender fields, has come across a conveniently tethered horse, minding its own business while she debates what to do next. It doesn't look a very ardent debate – and in any case the truth of the matter is that the horse's owner also owns the field and happened to come riding along, on his way home for an aperitif. And since everyone knows that, next to water, girls ought to be photographed with horses (it's ancient chemistry and doesn't reward pondering, only admiration) a snap was inevitable.

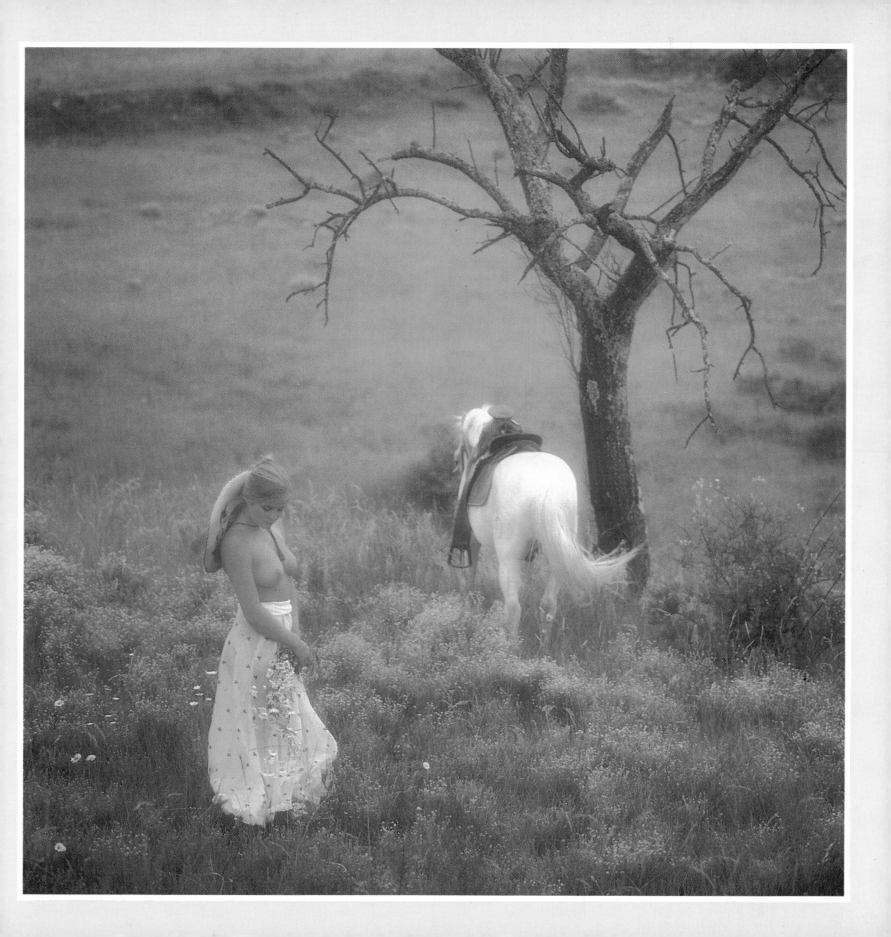

Karen. And in the background, the archetypal French village. Quite what a girl is doing with a mirror which doesn't look even remotely efficient is not our concern. The original title of the Calendar was to have been 'Secrets' and the thing is littered with devices of this sort.

Suffice it to say that it was subtle to the nth degree – to the point where you really need to scrutinize the reflection.

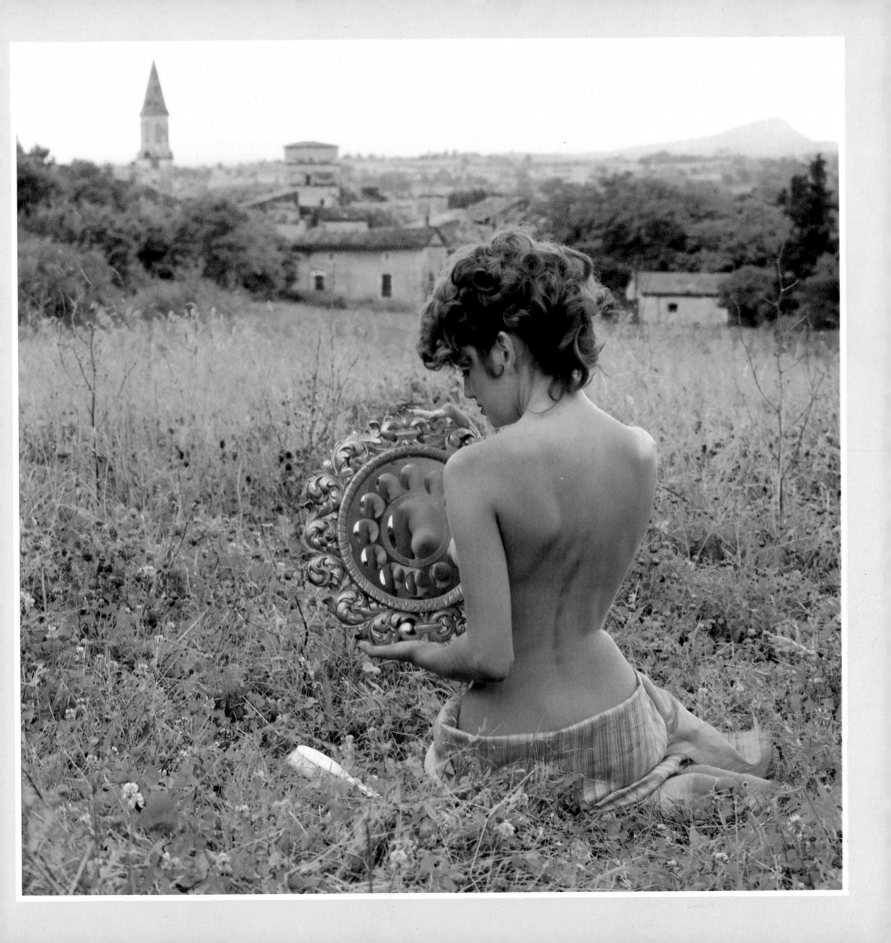

This one didn't make it into the Calendar.
Karen, poppies, a picnic got up by Annie,
a long lens and dusk. Beautiful, but in the
end they chose a long shot in which the
girl is almost incidental to the waving corn.

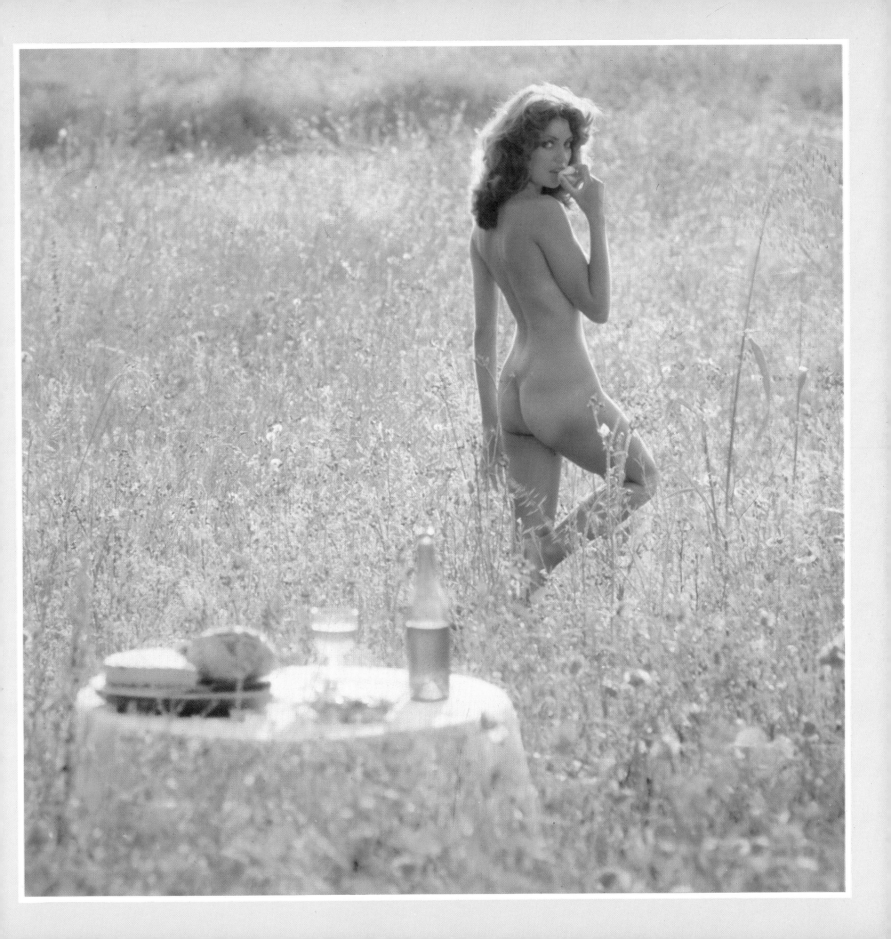

It looks calm enough. Actually, a
determined French tractor driver had just
blasted across, by the ford about where the
camera and a somewhat dampened
photographer are.

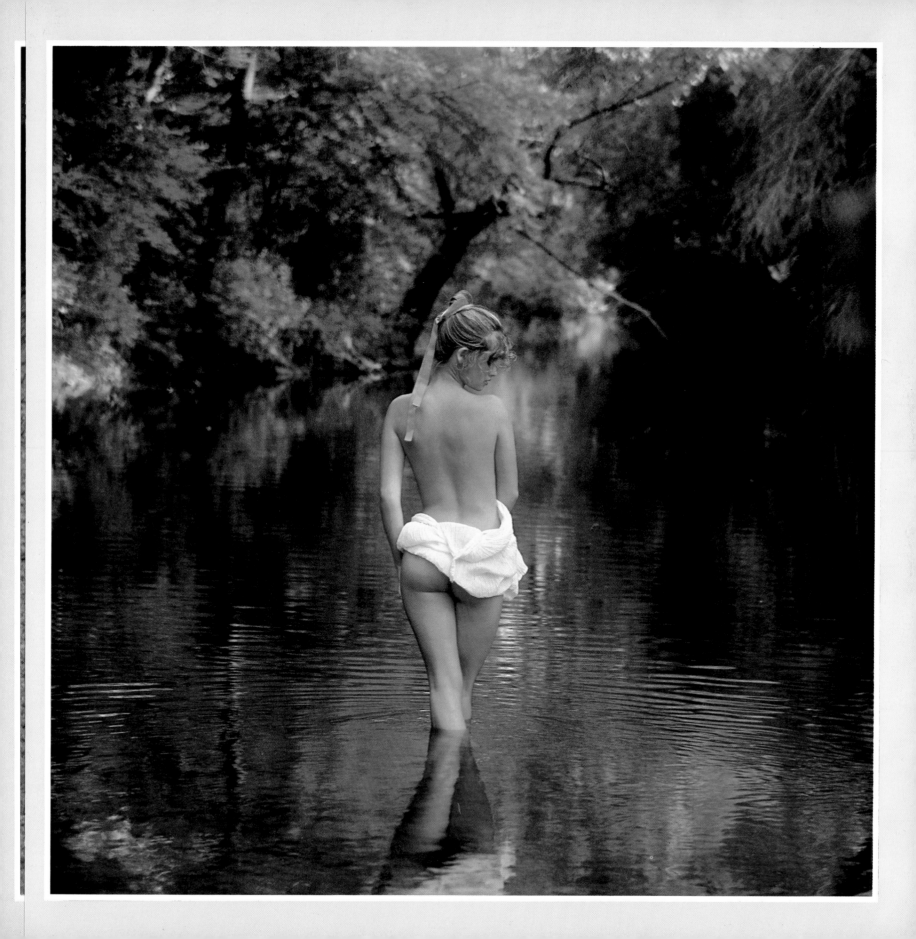

More subtle devices. Lichfield and his two staunch assistants, Chalky and Peter, are caught clustered in a chrome-tinted bauble which Karen, the Miss Australia of her day, is supposed to be intent on studying. Perhaps she's seeing herself trapped with doves in the castle tower.

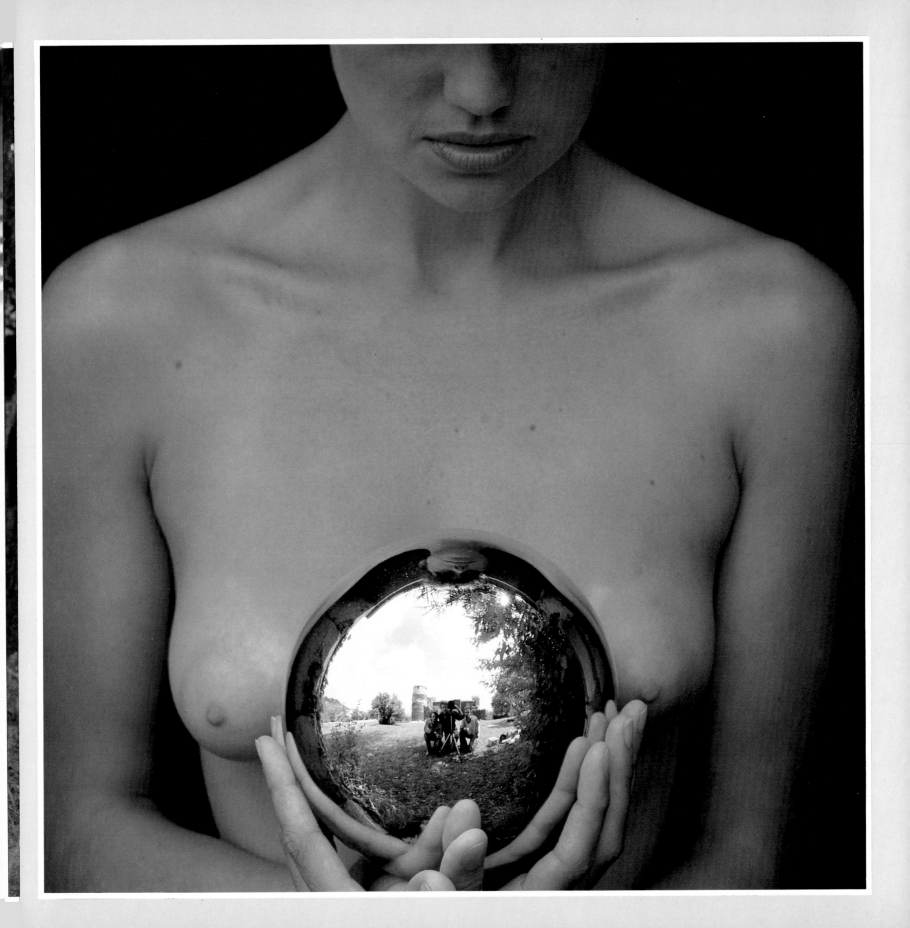

Spot, everybody's heroine, down by the
bayou. Here she's in her Huckleberry Finn
mode: boyish, makeshift and fancy-free.
Do you really catch crabs with a line?

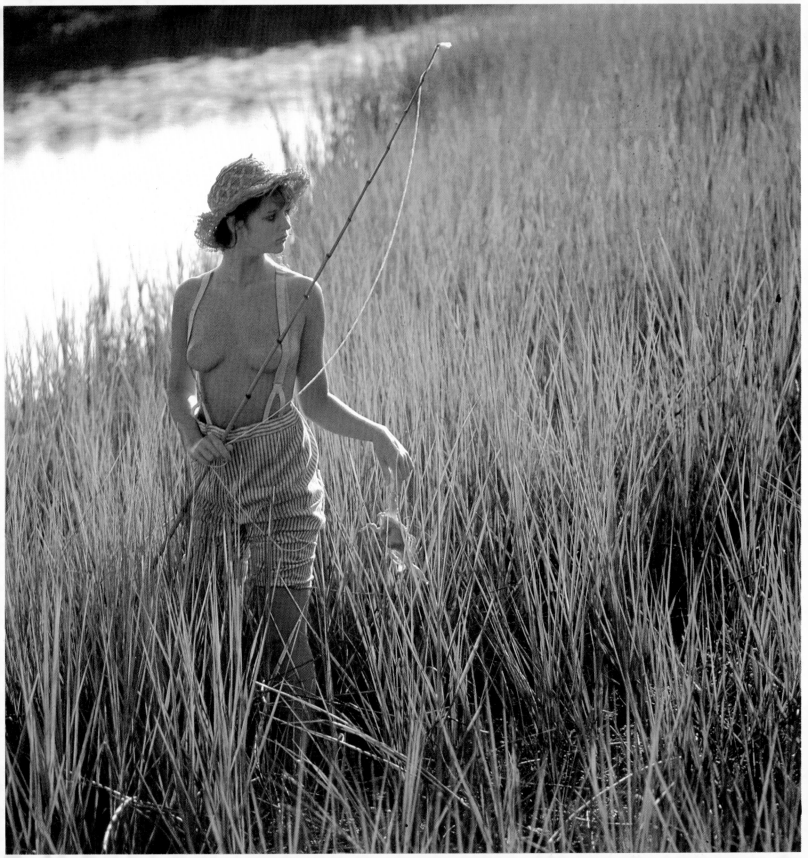

In South Carolina the team didn't take many shots away from their chosen plantation house – the locals didn't at all approve of nudes.

This is a perfect example of the Lichfield Empty House Aesthetic. He quite naturally finds it good fun to put enigmatic figures into enigmatic locations, where there are all sorts of delicious speculations to spray into one's gawping. It's the *Gone With The Wind* Factor. What sadnesses are presumed to lurk? What lover or husband, hero or card-sharp is this girl supposed to be thinking about?

The only certainty is that somebody's made off with the G-Plan.

THE
DEEP
SOUTH
1980

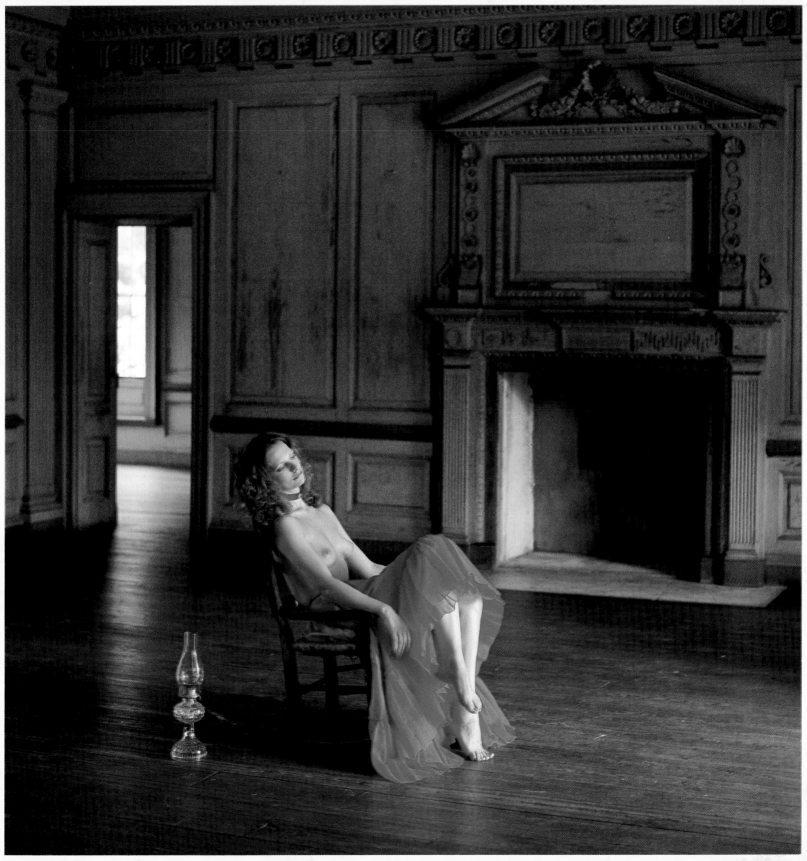

Spot with a butterfly. What, any sane
person might enquire, is this Southern
demoiselle doing in her flowing bits of lace,
under a straw hat, with a butterfly net?
Why isn't she cavorting with the gardener's
boy? Why not fending off a lustful uncle?
Or getting it together with a distant cousin?
But there you are: this is the world of the
Calendar – you're not required to
understand what's going on, just to enjoy.

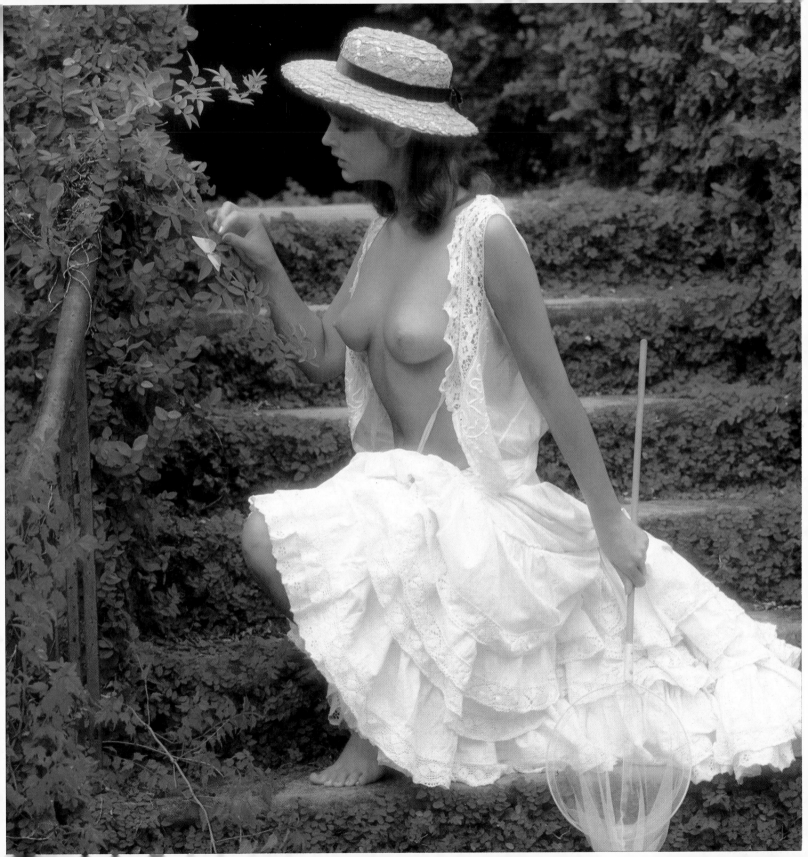

There was so much brilliant, reliable sun
in South Carolina that the team were
pleased often enough to find a shot to take
away from it. So it was tempting to
arrange the kind of haystack idyll that a
sceptic might suggest could just as well be
found at home. Except that it is a kind of
luxury to know that any day of the week
the sun will razor into even this strawed
recess, where Spot is clearly wondering
how to spend the afternoon.

THE
DEEP
SOUTH
1980

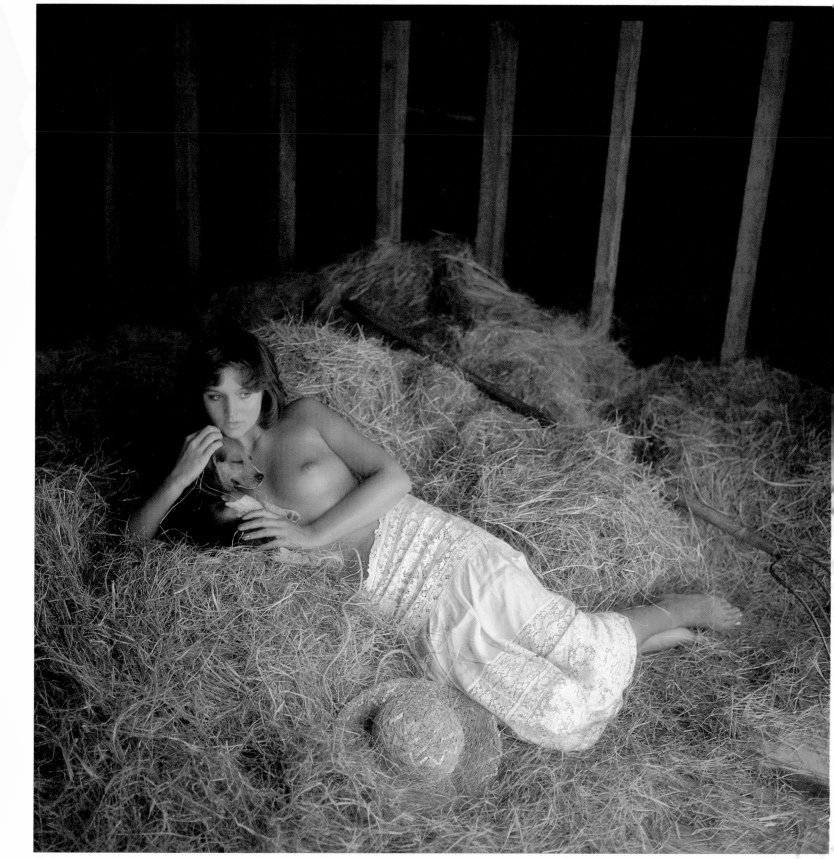

The best approach to combining art, sex
and purity the Calendar has yet managed.
It isn't a very probable sight to see every
day of the week, for sure. But there's
something so assured about Spot's attitude
to being corsetted, chokered, pot-planted,
framed and discovered, that it all adds up.

Lichfield says it's a prime example of
where styling makes all the difference:
Annie's little raiding parties have yielded
up just what's needed.

THE
DEEP
SOUTH
1980

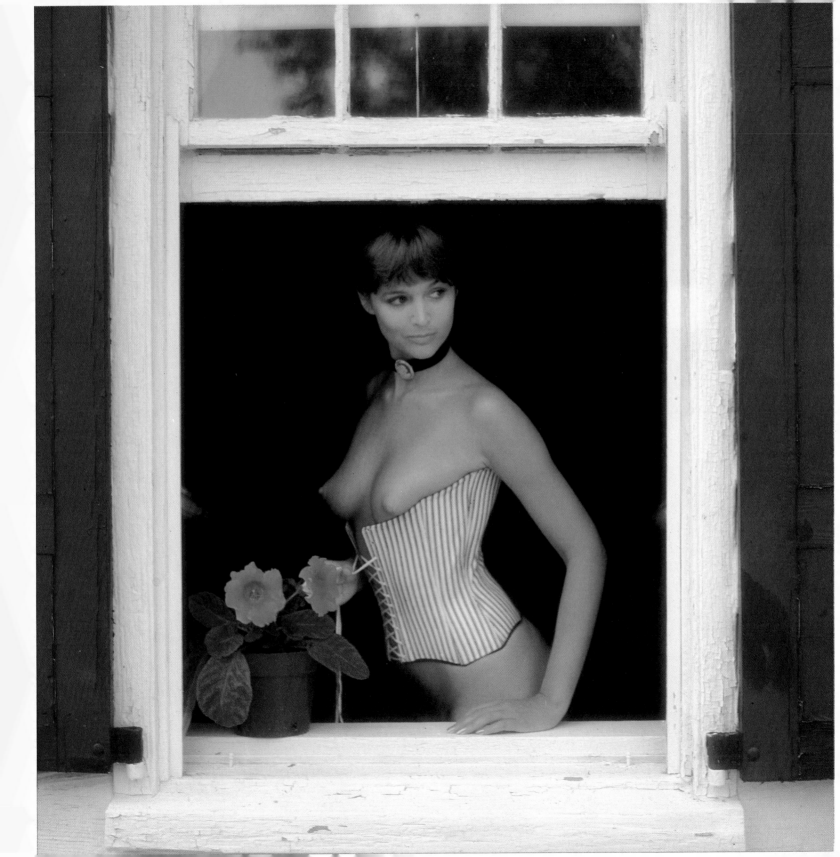

Angela on a swing. Specially rigged, of
course. This is a very pre-Raphaelite little
number. Perhaps it's the ivy; perhaps it's
the flowering shrub on the left (it was
patiently faked by a team who don't at all
mind improving on nature).

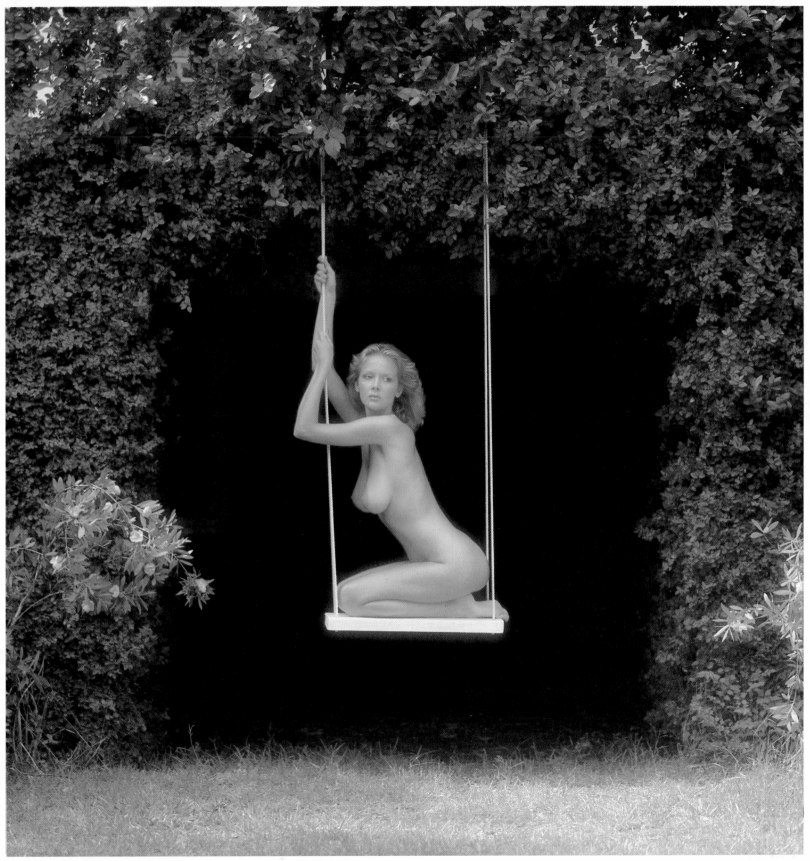

Angela again. She's just escaped, one's inclined to surmise, from the cottage. A breath of air between clients? Or a Tennessee Williams-style refugee from a roughneck husband who knows how sensitive she is and is pretty darned sensitive himself, but can't quite get it across to her?

The Annie Calvas Blanchon touch is to be spotted on the right: the rocking chair that puts you in the southern States.

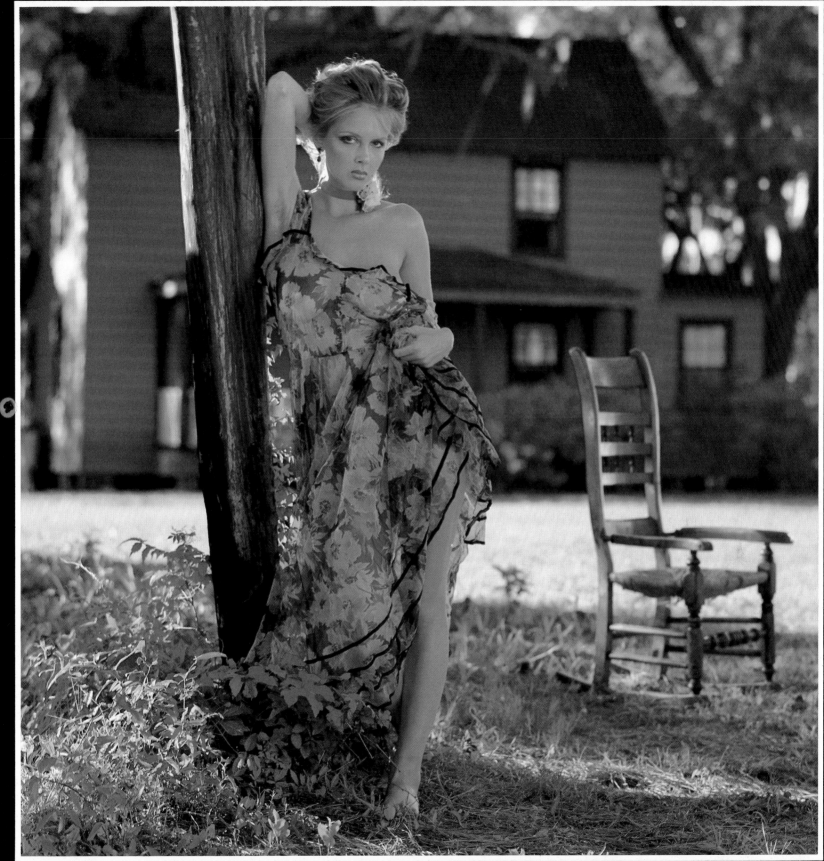

There's only one horse left at The Wedge,
the plantation house owned by the liberal-
minded Russian emigrée who didn't
trouble who did what on her property
provided they had fun. This is Angela
equipped, up to a point, to go riding –
she's got the boots and she's got the horse:
they're seen here establishing rapport.

This is, as you'll have noticed, what is in
the trade called a leg-shot. This is partly
because it was taken late in the Carolina
shoot. 'By then,' says Lichfield, 'we were
taking pictures of the girls in whatever
way we could that didn't show where
they'd been bitten. The mosquitoes were
extraordinary.'

THE
DEEP
SOUTH
1 9 8 o

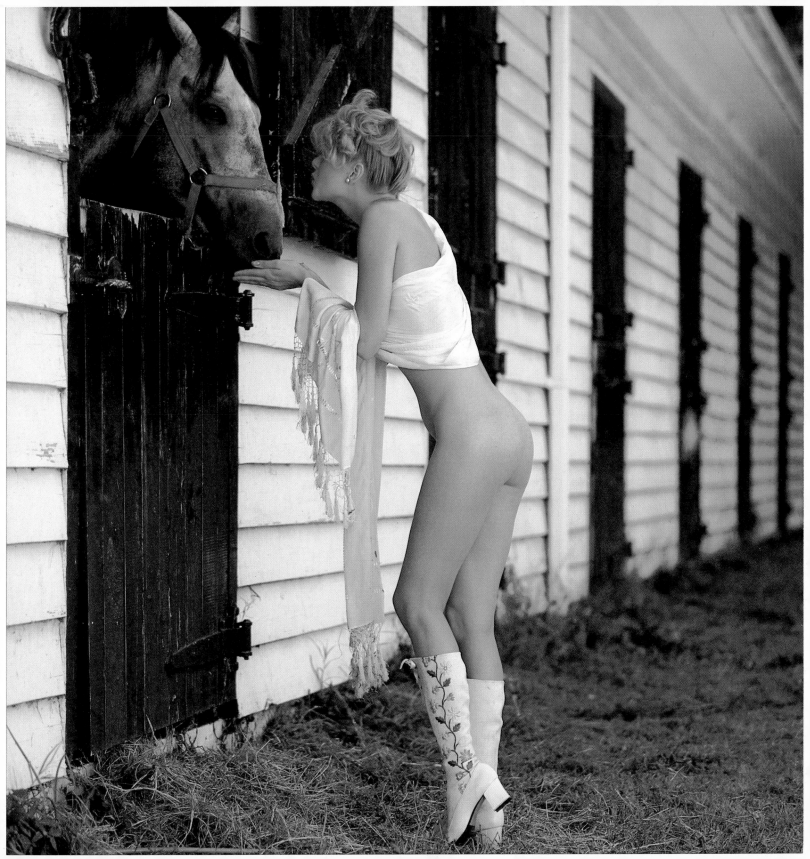

'A long lens,' says Lichfield, 'to make sure
the Spanish moss is in focus as well as the
girl.' Quite why a young white missy is
doing a Creole out of a star part is
anyone's guess. Lichfield's inclination is
to go for a good picture and not be too
hung up over the requirements of ethnic
accuracy.

If Lesley-Anne had been spotted by the
locals, she, the photographer and all his
cohorts would have been up before a
Bible-thumping judge, whipped round to
the slammer and the key thrown away.
But that's the price of art.

THE
DEEP
SOUTH
1 9 8 0

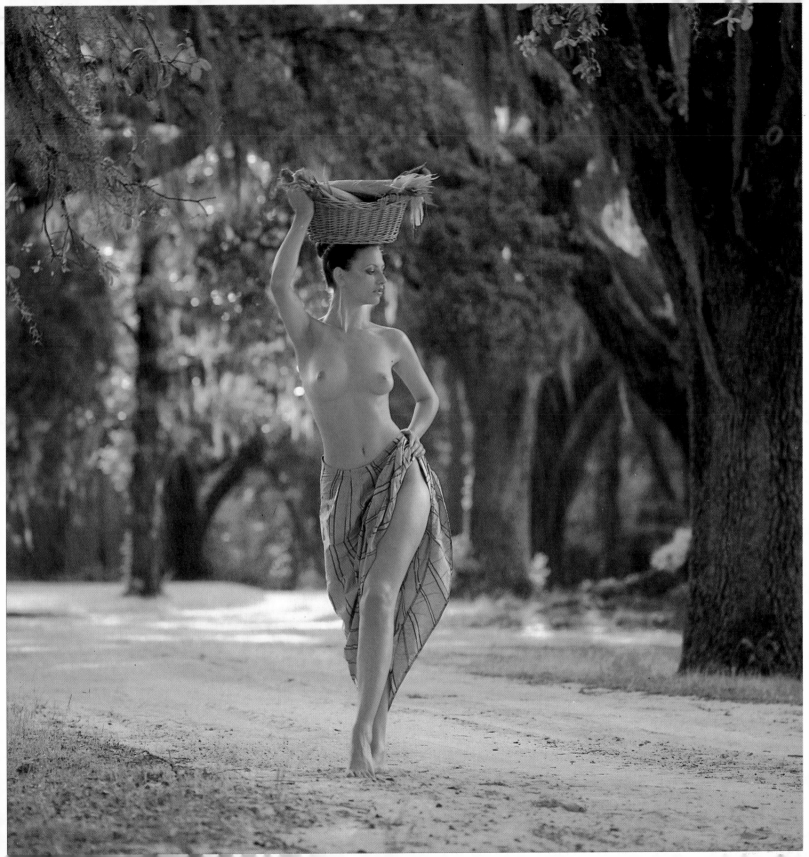

Sheree succumbs to the sun in Kenya for
the 1981 Calendar. The locations
themselves often threatened to take over as
stars: it happened, as it probably will with
professional models around, that Lichfield
came across Sheree one late afternoon in
more or less this pose, with the miniature
waterfall ironing out whatever ails a spine
like hers.

At first he was cross because once again
she was baking herself out of any chance
of looking even remotely just bronzed,
let alone the favoured white-pink of a real
White Lady caught unfrocked. But then
he suggested a couple of minor alterations
to the pose and took the snap anyway.

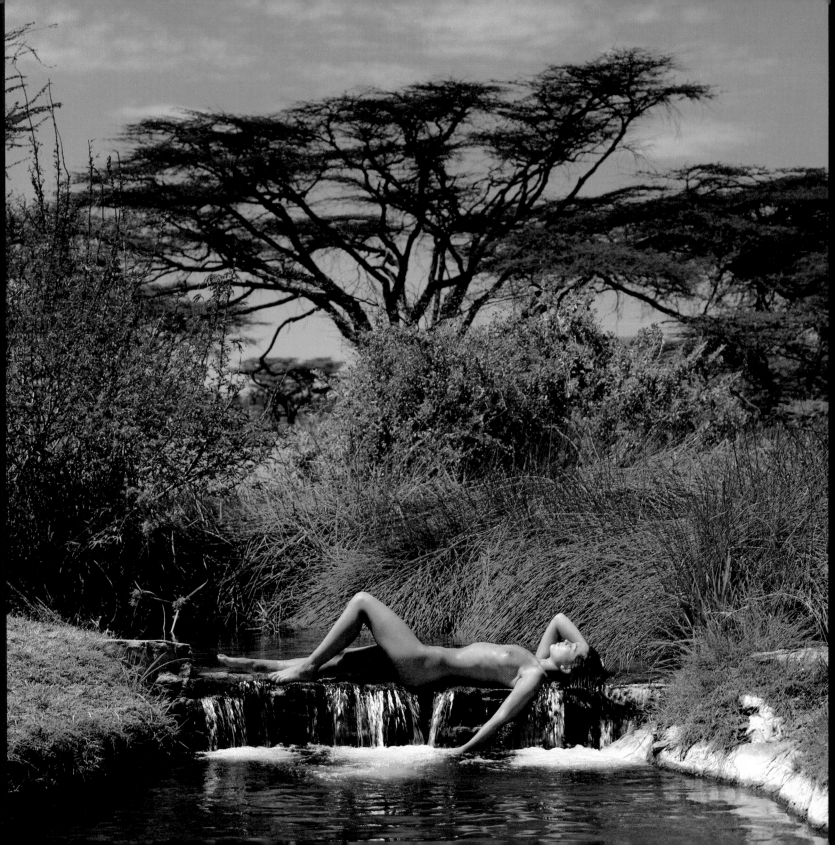

THE
EQUATOR
1981

Melissa – you're supposed to believe, and
more of this later, that she's a missionary's
daughter. And, being a missionary's gel,
she likes bikes. Girls and water, of course,
are two of the great mysteries. Add a bike,
even if it must risk rust and woeful damage
to its bearings and parts, and there's a kind
of magic most village streams lack : this is
the Ewasau Ngigro river doing its bit.

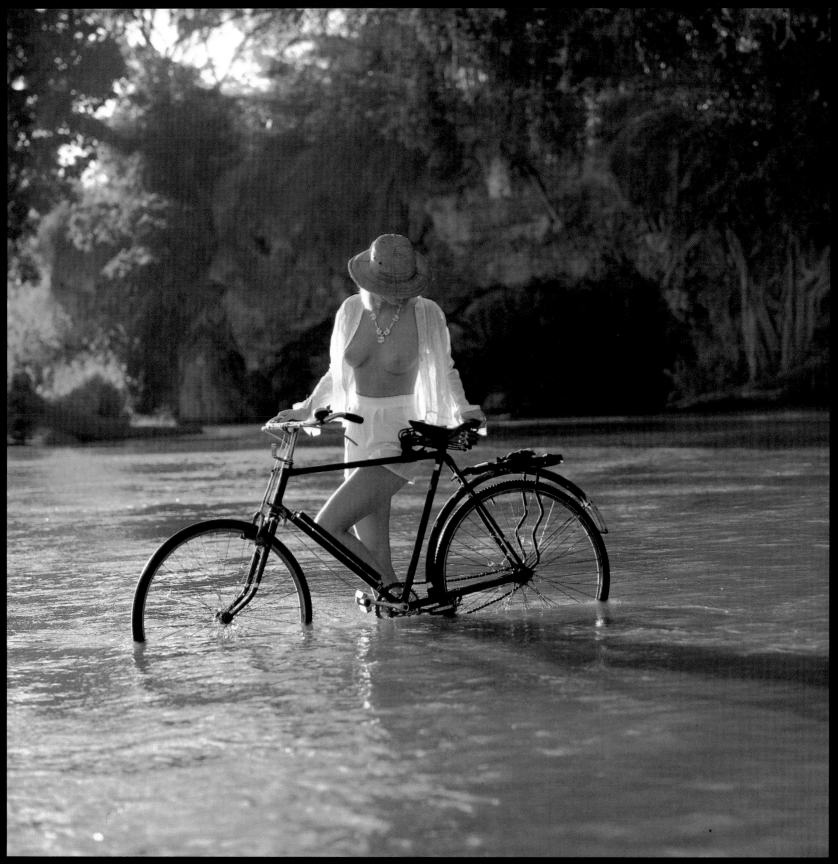

THE
EQUATOR
1981

Lake Begoria, formerly Lake Harrington
(apparently he was a bishop – perhaps he
was a missionary, too).
Melissa was sent stalking very slowly to
the water's edge. Lichfield and the team
kept in the background, and it is the long
lens which concertinas the scene.

The flamingos – the lake sports the world's
largest single population of them – are not
much taken with intruders and haven't the
nous to know that Melissa is not equipped
for slaughter.

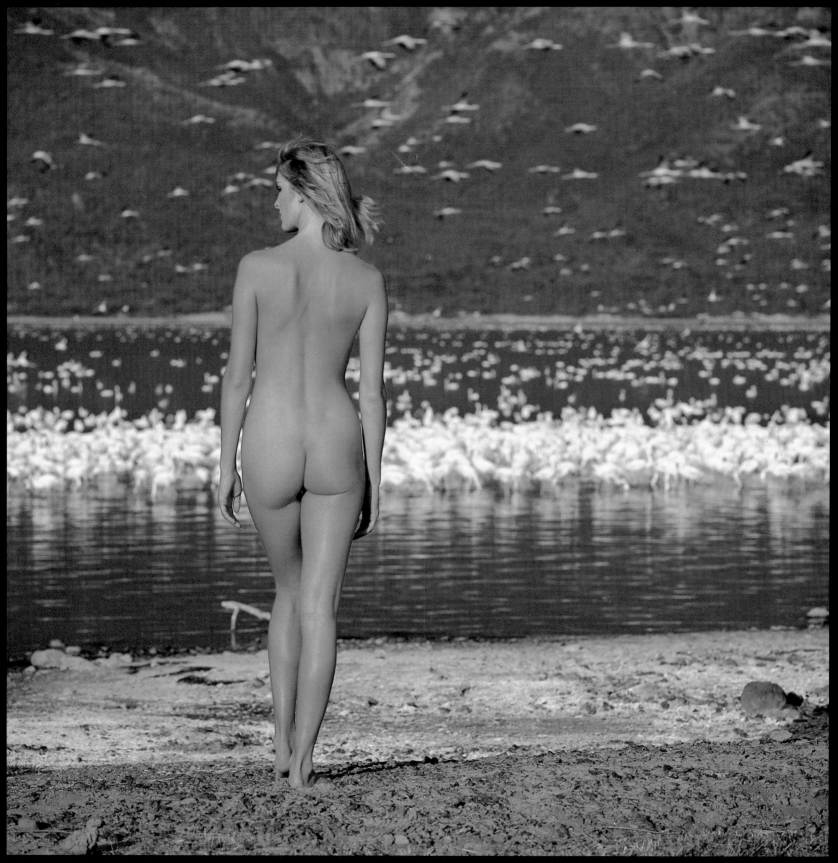

THE
EQUATOR
1 9 8 1

Sheree's persona in Kenya was American-style hitch-hiker, here getting around by herself. In truth, of course, there's no movement at all -- the ferocious bike-lady's hair is looking remarkably composed. And they had to crop the bit of the picture which showed the front tyre to perfection – every tread clearly on view and clearly immobile.

The crew were all madly flapping fronds to stir up her dust, but if the fantasist won't play his part in such enterprises they'd never get started. Oddly enough, without the bangles and the necklaces, the picture wouldn't look anything at all. There's something in the quality of the sunlight, though. And there are people who like girls on bikes. But the real fun only starts when the witch-doctory stuff comes to the fore.

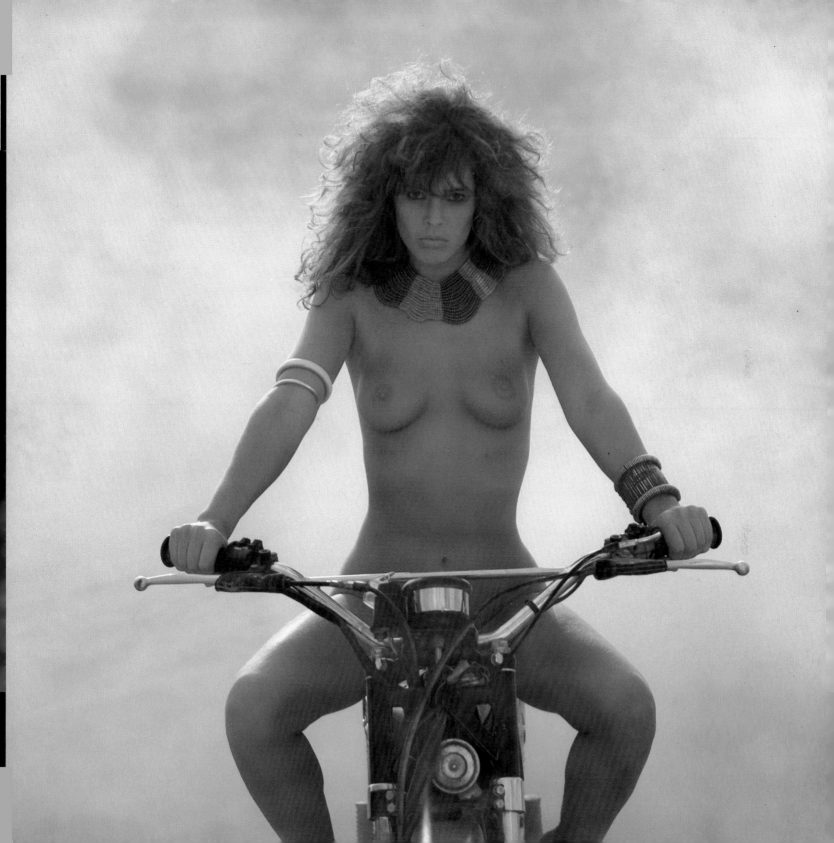

THE
EQUATOR
1981

Melissa, being a missionary's daughter,
always did like to keep herself scrubbed.
She had a hard time with this piece of
elegance: the water at Chandler Falls
plummets a hundred feet – she'd have
needed corrugated skin to disport beneath
it for long.

The picture was taken late in the
afternoon, on a very slow exposure, to help
the water take on its milky appearance.

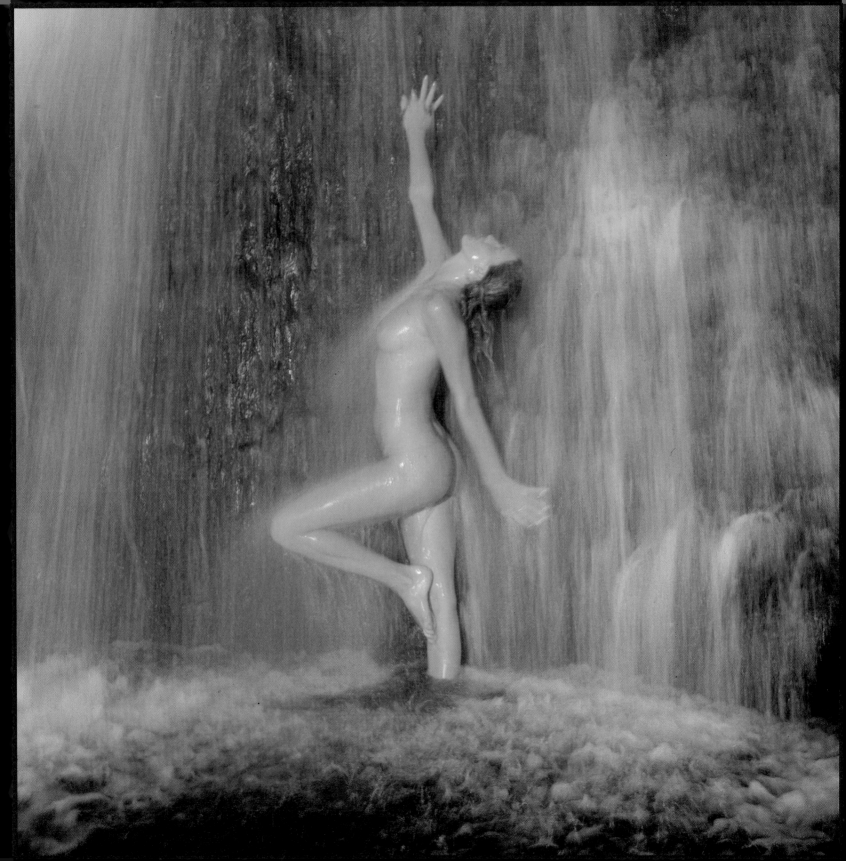

This is Sheree doing what Sheree was
supposed to do: actually thumbing it in
Shaba. The pose in the end was not best
suited to please at least one member of
the team: Clayton and Sheree had been up
since before dawn fixing her make-up
which did not, in the end, exactly feature
prominently.

What the motorist thought of it all is
anybody's guess. Perhaps he was the
missionary, rushing to rescue his daughter
from waterfalls, flamingos and rusting
bikes.

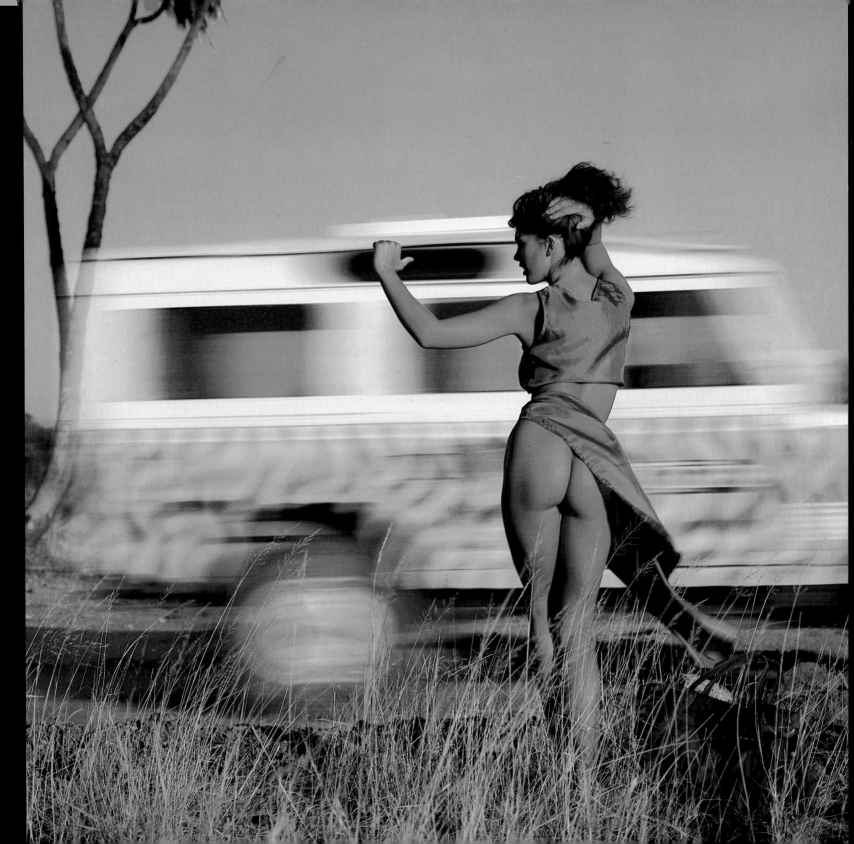

THE
EQUATOR
1981

Melissa is here doing what Katherine
Hepburn would never have been prepared
to essay. Ethiopian crucifix much in
evidence, she is the *African Queen* lady in
an old wooden tub, as taken by a
hypothetical Bogart, pole-axed in
admiration in the bilges on Lake Baringo.

There aren't enough months in the year:
Lichfield is rather sad that this is a snap
which Unipart's selection committee
eschewed.

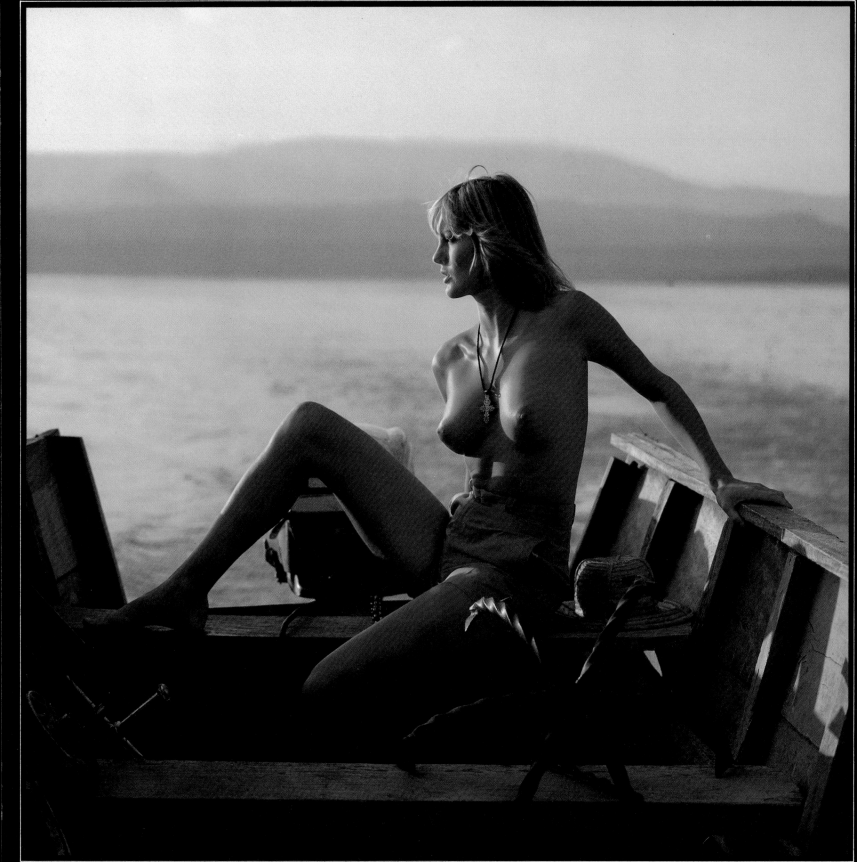

Clayton got to work more obviously in
Sicily than for previous Calendars and here
also has a walk-on part, aided by a Lichfield
tails-and-dickie.

The suggestion is irresistible that Claire
has just dined on a delicately par-boiled
tarantula or two, and that Mr Howard
has now made his entrance preparatory
to dining on her. Or at the very least
quenching his thirst on her jugular. But
there's no clue what thoughts she might
conceal behind her negligently dangled
sequined mask.

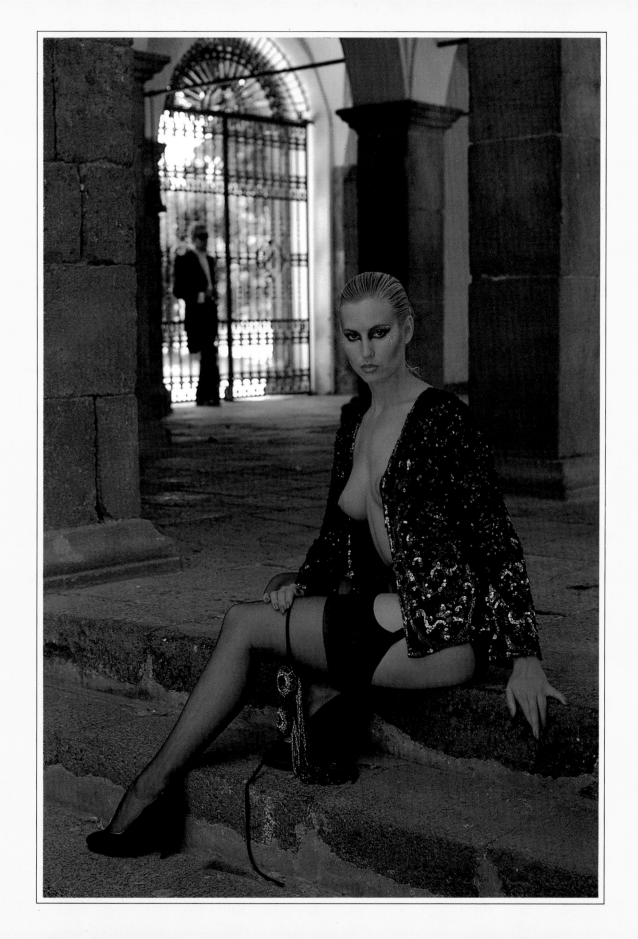

This is as near as you can hope to come to pure art in a Unipart Calendar. As understated as a cucumber. As refreshing.

Suzi has come to rest against a frieze. You couldn't make a tale out of it if you tried. But, on the other hand, you couldn't easily resist the sheer prettiness of the colours. Lichfield says they took Suzi on the trip half-supposing she would be able to play a Sicilian toughie. Not a bit of it; she always looked vulnerable in the end and they soon gave in to it.

SICILY
1982

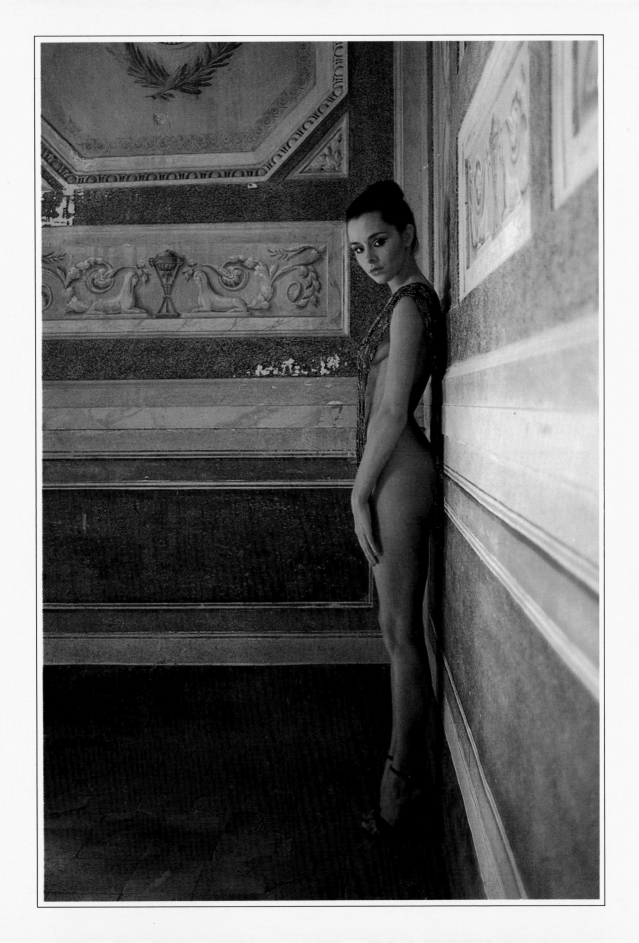

Claire in the main drawing-room of Maniachi, the Nelson residence. The decanter and glasses from which Nelson, it is said, took his last drink before the Battle of Trafalgar are on a nearby table. But Claire has other things on her mind. She looks faintly as though she may be taking time out from a debauch taking place within. Or is she on the reserves bench?

Lichfield was able to work on all through the day in Sicily: inside, or in the court-yard, the sunlight pounding down set up just the conditions he needed indoors or in a shadow.

SICILY
1982

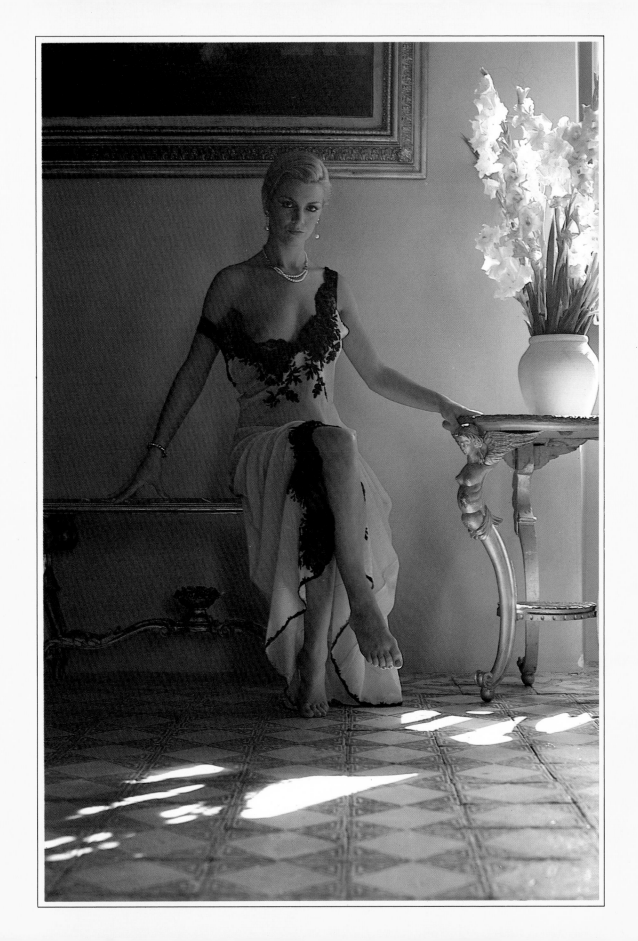

Claire in another of the several, immense
lovely near-derelict houses of Sicily, near
Palermo. There was a man in the garden,
pottering; and men on the roof, loitering.
And here, for all the world, the mistress of
the place doing her rounds. The cranky
concierge our team found on the premises
was a very strict sort of housekeeper, so
for once the model kept most of her
clothes on.

SICILY
1982

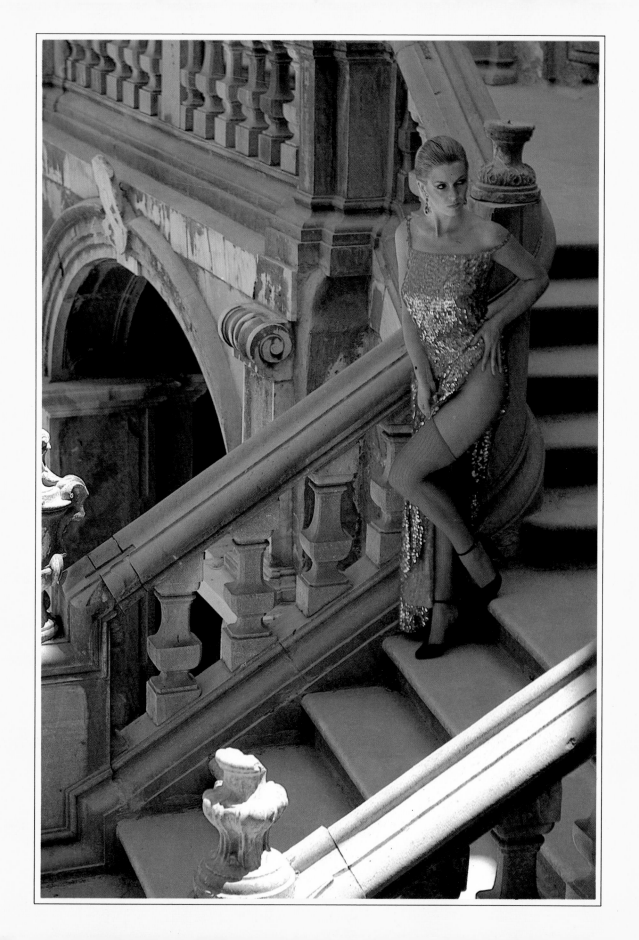

A Sicilian Dark Lady? Suzi's face, bat-like, made-up to perfection, is etched onto the picture. What might be going on here? It probably doesn't pay to enquire, unless you fancy an hour every Thursday afternoon on some expensive couch telling your life story to a bearded Viennese.

Suzi's face is so sharply lit because, though she's in the shade, there's bright sun bouncing off the other three walls of the courtyard.

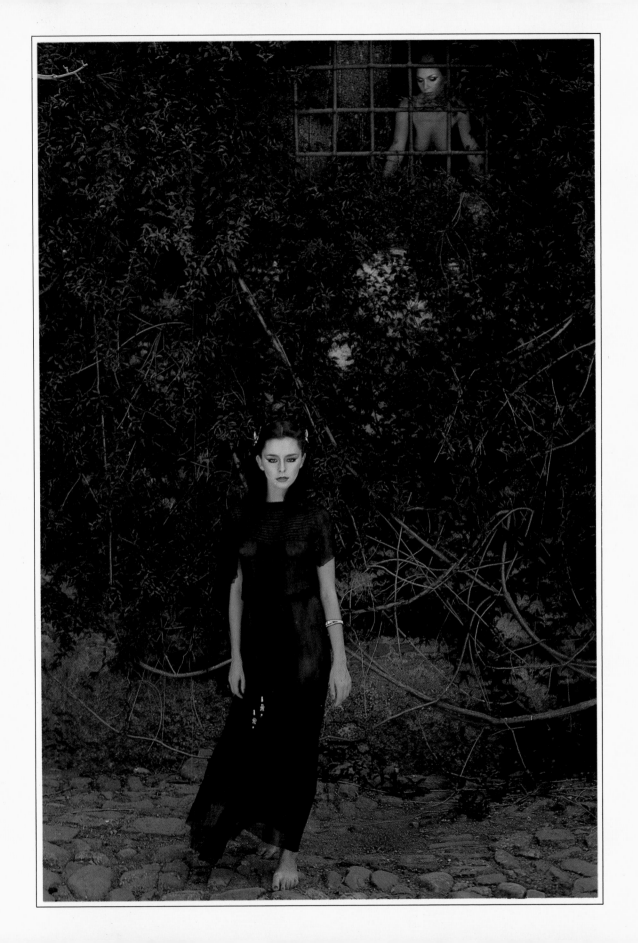

Claire, giving the cypresses a once-over in the Sicilian dusk, with lavender in the foreground beneath a duck's-arse hairdo which would do credit to the rear view of a dedicated, unreconstructed teddy boy. This is the classic Unipart 1982 shot: cheekbones worked overtime for the whole of this trip.

From a fashion point of view, aficionados will of course note that in this, the heart of some whimsical paradise, evening gloves *will* be worn with body stockings.

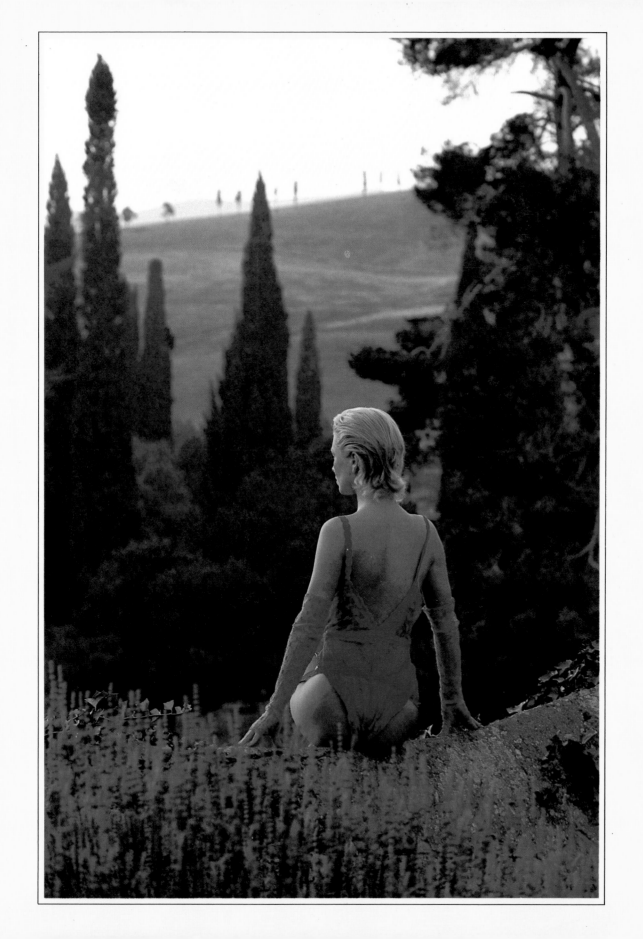

This was taken in the Palermo second-string location. You would have to be brave indeed to ask the lady why she was stood astride her ancestral home in a sequined *skull-cap*. These pretty aristos keep that sort of thing to themselves. Besides, Claire has a dagger whose role as costume may betray something more functional: she doesn't look the kind to waltz past in a hurry, nor to make impertinent enquiries of as to her eccentric choice of headgear.

Small wonder, with so much going on – an English lord, fleets of assistants in the vanguard and a lady like that – that the work on the roof slowed down a bit.

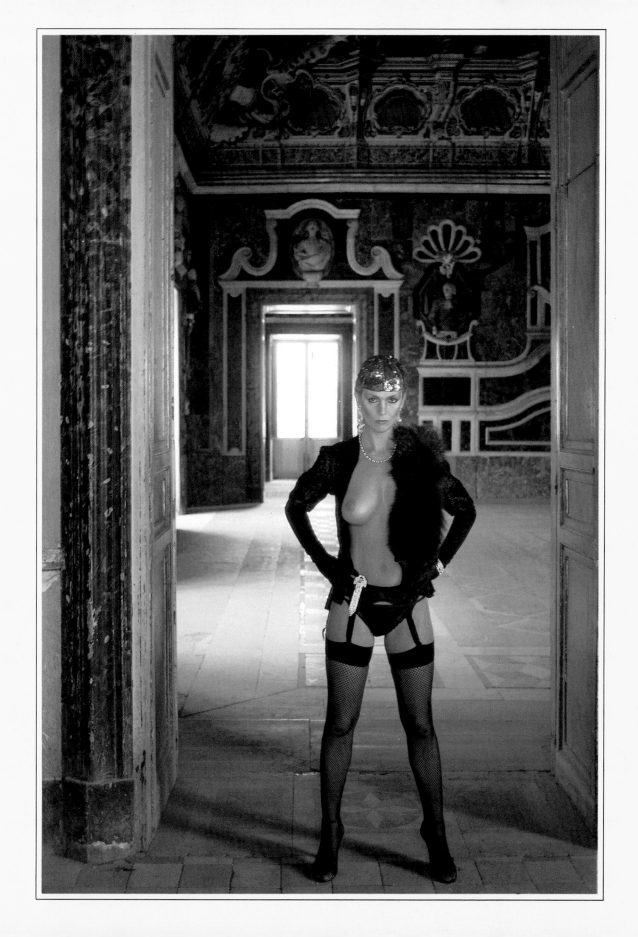

First thing in the morning. The light streams in through the six windows of the corridor from which all the Maniachi bedrooms run. You are supposed to imagine that Claire (pearls, silk blouse, severe skirt) is the none-too-efficient gaoler or wardress or some such to young Suzi, who is the flit of flesh shimmying past.

'It took,' Lichfield says, 'a long, slow exposure. And Suzi had to jerk-walk, so her image is frozen on the exposure several times.'

SICILY
1982

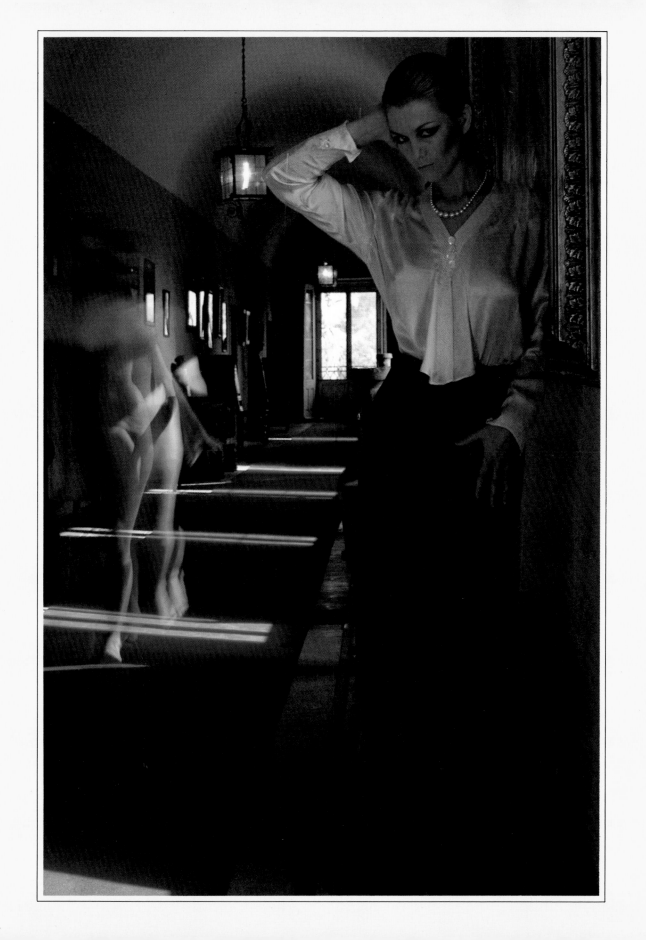

Suzi at Maniachi's gates. Not even Nelson could have felt himself (the 'N') more effectively bonded to his new Bronte estate (the 'B') than by this curiously dangerous sylph. Nor would he have needed any reminding from the letters NB. Suzi is not a girl you drop from mind, even if she's giving you that goodbye look.

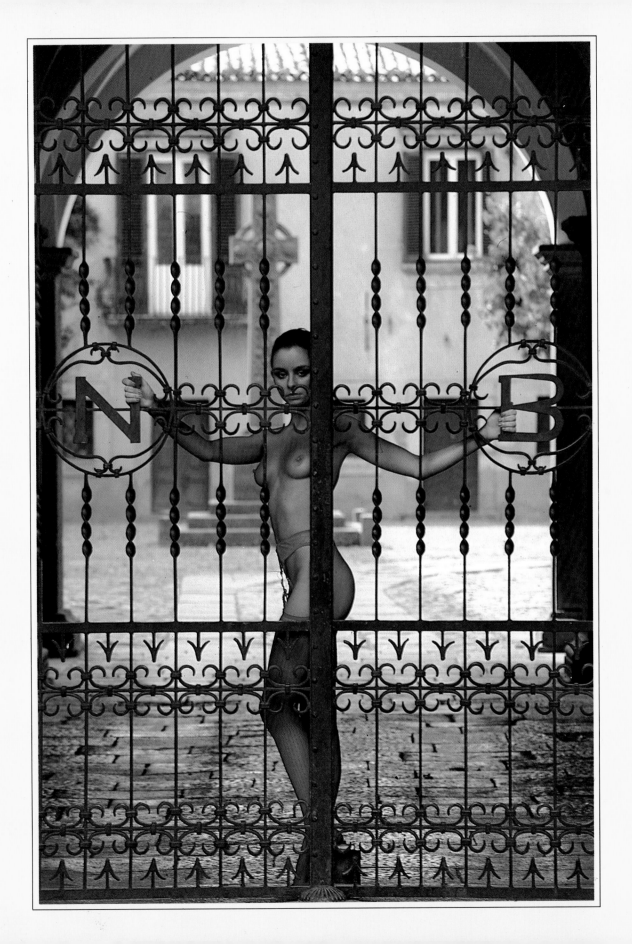

When the King of Naples gave Nelson a Sicilian house and estate to honour the newly-created Duke of Bronte, there can't have been much expectation that it would do its last duty for the nation by having models draped all over it.

Lord Bridport, Nelson's direct descendant, was about to sell Maniachi when the team arrived and the 1982 Calendar was shot there just as it changed hands.

Here, Ross, Suzi and Claire do great things for the louvres upstairs. Sebastian Keep sits on the left of the gateway and Chalky Whyte sits bottom right. Clayton Howard and Annie Calvas Blanchon flank the awesome duo: Lichfield (left) and Noel Myers, whose occasionally tempestuous working relationship seems to have subsided into truce for this, the annual group shot.

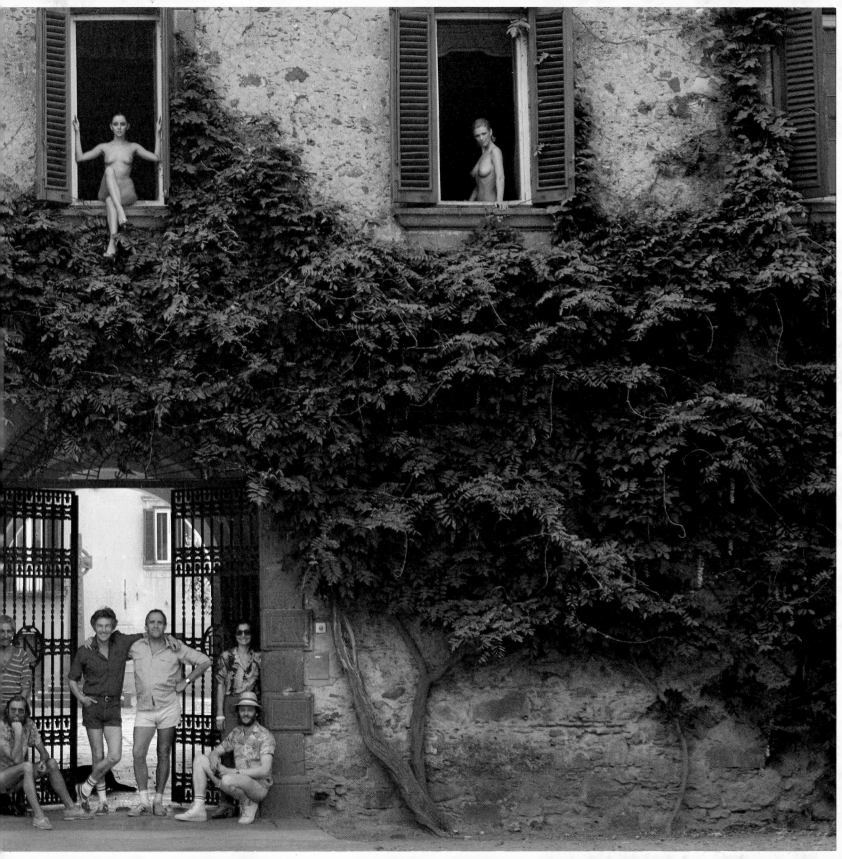

TECHNICAL NOTE

CAMERAS AND FILM

We used the Hasselblad (medium format), with the majority of shots taken with a 150mm lens. The slight telephoto effect compresses backgrounds somewhat and avoids distortion which can prove unattractive in glamour photography. For more marked telephoto effects a 350mm lens is used.

We also used the Olympus (35mm format) and we found an 85mm fixed-focus or a 75–150mm zoom lens provided the ideal perspective. In Sicily we also used the 55mm lens extensively to include more of the environment and also to utilize the wider lens openings available. This was necessary because many of the shots were taken in low light (interiors) on Kodachrome 25.

Kodachrome is the film we tend to prefer for 35mm work because of its colour saturation and almost complete lack of grain; these factors make it the ideal medium for reproduction purposes. With the medium format camera we rely on Ektachrome, which allows us the added safety of being able to clip-test every roll and, if necessary, to adjust the development of the rest of the roll in order to bring the brightness of the transparency to perfection. This is important for the quality of skin-tones – and with so much skin on show it becomes vital.

Before embarking on a Calendar shoot, as with any extended shoot where several hundred rolls are to be used, a batch of film is purchased and must be tested under all the conditions which we are likely to encounter on location. This allows us to gauge what amount of filtration we will need in order to correct the colour characteristics which are inherent to that particular batch of film. Once again, with so much emphasis laid on the quality of the skin-tone, it would be embarrassing to travel thousands of miles only to look at the transparencies on the studio light-box and see a green tinge in those expanses of naked skin.

LIGHT

Travelling to foreign parts isn't for the benefit of our suntans: models, especially glamour models, usually carry a healthy tan with them all year round, thanks to frequent visits to Uvasun or a similar solarium. Indeed, they are often discouraged from exposing themselves to the sun because if a tan becomes too deep the film doesn't see it in as attractive a way as does the eye: strange hues begin to creep in and destroy the effect. Wherever possible we do try to utilize natural light but we also try to avoid direct sunlight on a model unless it is very early morning or late evening, when the low sun is more diffused. We worked at these times extensively in Kenya, shooting sometimes at six in the morning; the hitch-hiker shot is a classic example – warm light on the skin and that marvellous shadow cast onto the Land Rover. The mid-day sun was, however, utilized in the umbrella shot (cover) to show by the shadow that the sun was overhead and burning.

More often than not, though, we backlight the subject and reflect light onto her with white deflectors in order to balance exposure and fill in the shadow areas. Sometimes, as with the Sicilian shot with Suzi outside the gaol and Claire in the window, the mid-day sun blasting into the courtyard created a natural reflector, giving Suzi that strange luminosity.

On some occasions it is necessary either to supplement or simulate daylight with electronic flash. In these instances we take great pains to soften and diffuse the light source in order to minimize shadows, usually by bouncing it off a light, neutral-coloured surface. Here again, the colour temperature of the light source is of paramount importance and this is tested prior to the shoot. For electronic flash we used Bowens or Broncolour, the latter having the largest softlight source available which, we feel, approximates closer than any other to a window light.